P9-DDF-419

Painting
Romantic
Landscapes

Sharon Buononato, CDA

NORTH LIGHT BOOKS

CINCINNATI, OHIO

www.artistsnetwork.com

About the Author

Sharon Buononato was first introduced to decorative painting in 1979 and started teaching in 1980. For Sharon it was love at first brushstroke. She joined the Marlboro Society of Tole and Decorative Painters in 1982 and received her CDA certification in 1987. She presently holds memberships in two of its chapters, Capitolers in Albany, New York, and Hudson Valley Tole and Decorative Painters (HVTDP), where she held executive positions from 1990–1994. Sharon has attended ten national conventions where she taught classes, provided demonstrations and managed her own booth.

Many of Sharon's projects have appeared in *Decorative Artist's Workbook*, *Artist Journal*, Japan Decorative Painting Association (JDPA) and *The Decorative Painter* magazines. She has designed over forty-five original packet designs, three instructional books and four videos, and has designed her own line of technical brushes.

Painting Romantic Landscapes. Copyright © 2002 by Sharon Buononato. Manufactured in China. All rights reserved. The patterns and drawings in this book are for the personal use of the decorative painter. By permission of the author and publisher, they may be either hand-traced or photocopied to make single copies, but under no circumstances may they be resold or republished. It is permissible for the purchaser to paint the designs contained herein and sell them at fairs, bazaars and craft shows. No other part of this book may be reproduced in any form or by any electronic or mechanical means including information storage and retrieval systems without permission in writing from the publisher, except by a reviewer, who may quote brief passages in a review. Published by North Light Books, an imprint of F&W Publications, Inc., 1507 Dana Avenue, Cincinnati, Ohio 45207. (800) 289-0963. First edition.

Other fine North Light Books are available from your local bookstore, art supply store or direct from the publisher.

06 05 04 03 02 5 4 3 2 1

Library of Congress Cataloging-in-Publication Data
Buononato, Sharon
 Painting romantic landscapes / Sharon Buononato.--1st ed.
 p. cm.
 Includes index.
 ISBN 1-58180-160-2 (alk. paper)
 1. Landscape painting--Technique. 2. Romanticism in art. I. Title.

ND1342 .B86 2002
751.4'26--dc21 2001045021

Editors: Bethe Ferguson and Christine Doyle
Production Coordinator: Emily Gross
Designer: Joanna Detz
Layout Artist: Linda Watts
Photographers: Christine Polomsky and Al Parrish

Metric Conversion Chart

TO CONVERT	TO	MULTIPLY BY
Inches	Centimeters	2.54
Centimeters	Inches	0.4
Feet	Centimeters	30.5
Centimeters	Feet	0.03
Yards	Meters	0.9
Meters	Yards	1.1
Sq. Inches	Sq. Centimeters	6.45
Sq. Centimeters	Sq. Inches	0.16
Sq. Feet	Sq. Meters	0.09
Sq. Meters	Sq. Feet	10.8
Sq. Yards	Sq. Meters	0.8
Sq. Meters	Sq. Yards	1.2
Pounds	Kilograms	0.45
Kilograms	Pounds	2.2
Ounces	Grams	28.4
Grams	Ounces	0.04

Dedication

Skill is a culmination of learned experiences gained through knowledge and application. I owe my skills to many wonderful teachers in my past and present painting education. The desire to paint was given to me as a gift from God and was nurtured by my mother, who is also an artist. Her favorite subject was landscapes, and her paintings are now family treasures. Watching her paint, applying her self-taught skills to create each scene, was true inspiration. Not one painting was sold, but instead they were given as gifts from the heart and soul. This book is dedicated to that complete love of painting that Isabelle King experienced and passed on to me. Thanks, Mom!

Acknowledgments

I would like to acknowledge Kathy Kipp and Bethe Ferguson for their patience and expertise in guiding me through this book. Also, thanks to the entire North Light staff whose combined skills have made this book a reality. Most of all, I want to express my deepest gratitude to my husband. He is always there encouraging me, solving problems and making everything possible. He is my best critic, and he has the wonderful ability to see through to the heart of the matter. Thanks, Lou!

Table of Contents

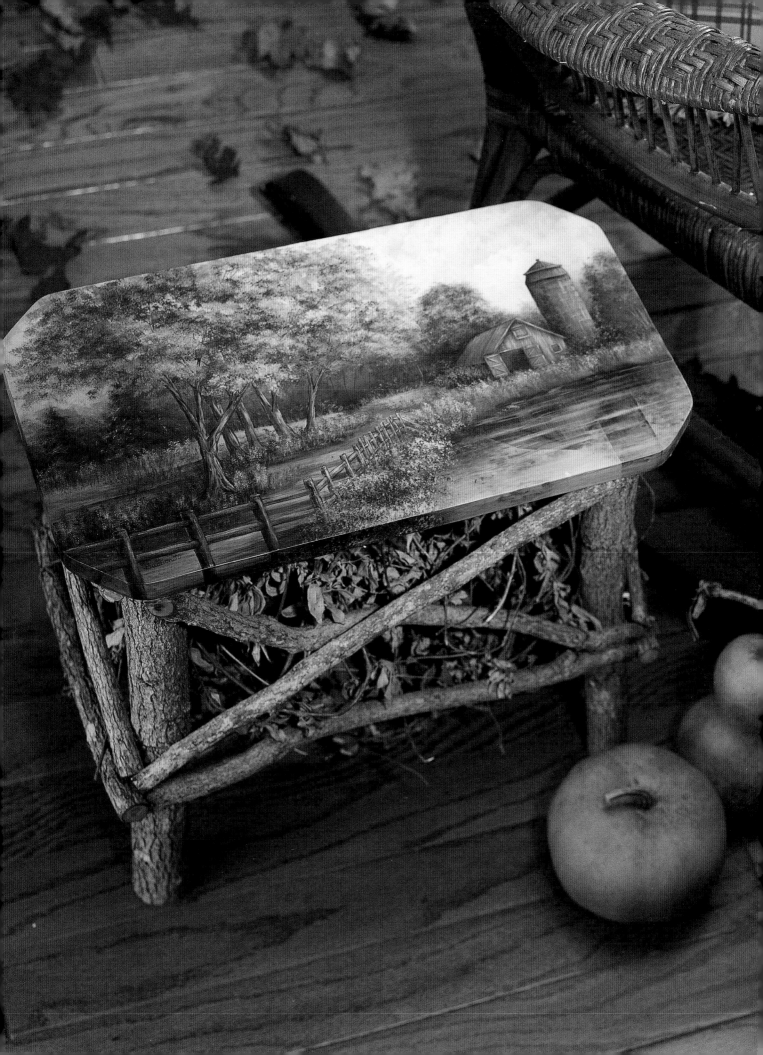

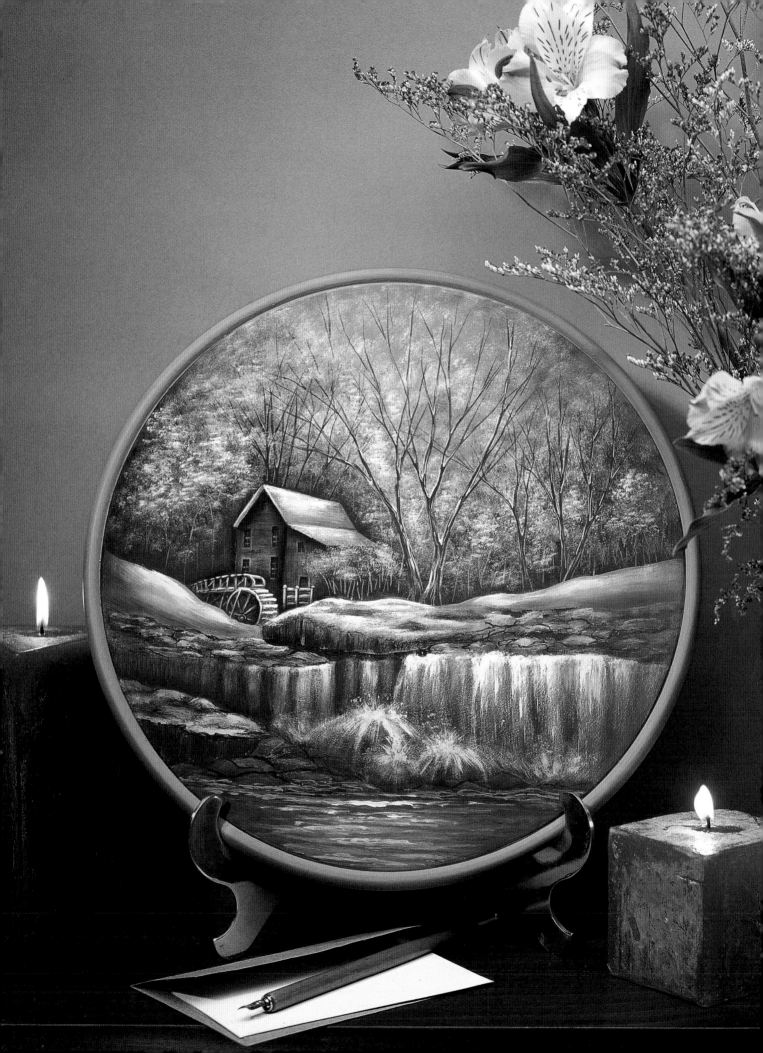

Introduction

Landscape painting with acrylics can be a very rewarding experience. It is my goal to provide the painting "tools" you will need to achieve my style of landscapes. I present these tools to you through step-by-step projects, photo guides, painting instructions and related materials, plus my own Sharon B's brushes. If you start with the first project and continue through to the last, you will progressively learn all the elements and skills. Anyone with a true desire can learn to paint successful acrylic landscapes. Happy painting!

Getting Started

BASIC SUPPLIES AND MATERIALS

Before I begin any project, I always make sure I have a few basic supplies on hand. You will be using these materials throughout the book.

- Tracing paper
- Gray and white graphite paper
- Stylus
- Clear, plastic ruler
- White eraser
- Pencil
- Masking tape
- Paper towels
- Lint-free cloth
- Water basin
- Apron
- Hair dryer and extension cord
- Scissors
- Cotton swabs
- Assorted foam brushes
- Extrafine sandpaper
- Palette knife
- Palette paper
- Sta-Wet palette

Hint

I recommend using a Sta-Wet palette only for saving paint mixtures. I prefer not to use it for brush-loading techniques because one, the extra water on the Sta-Wet palette slightly thins the paints. Two, it introduces additional moisture into the bristles while loading, which causes them to absorb too much paint. I recommend using a paper palette and small amounts of fresh paint for the brush-loading techniques in this book.

BRUSHES

The three brushes that I use in this book from my Sharon B's Originals line are the blade brush, crown brush and halo brush. I designed these natural-hair brushes to create very specific paint applications (see chapter two, page 14). They have natural bristles for several reasons. They will produce the desired effect with easy, consistent, time-saving applications. Their natural bristles are hollow, which allows them to hold paint for extended periods of time. Finally, most man-made bristles are not stiff enough to paint the effects I like to achieve or to stand up to constant use. As a natural-bristle brush ages from use, the bristles will become more open and stiff. This is a good thing! If you think the bristles have opened too much while painting, simply stop and clean them well with DecoArt DecoMagic Brush Cleaner. This product will get into the bristles and the ferrule and will loosen the paint. Rinse well with water and paper towel dry. I recommend that you finish drying with a hair dryer set on low-heat so you can resume immediate painting.

If you choose not to use my brushes, you may substitute stiff, natural-hair flat or angular brushes for the blade brushes, and round brushes for the crowns. Substitute a large stencil brush for the halo.

To apply washes and varnishes, I use Bette Byrd series 800 flat "wash." For other paint applications, I prefer to use Royal Majestic brushes. In this book I use the series 4250 rounds; series 4160 angulars; series 4700 flats; and series 4595 liners.

See Resources on page 142 for information on purchasing any of these brushes.

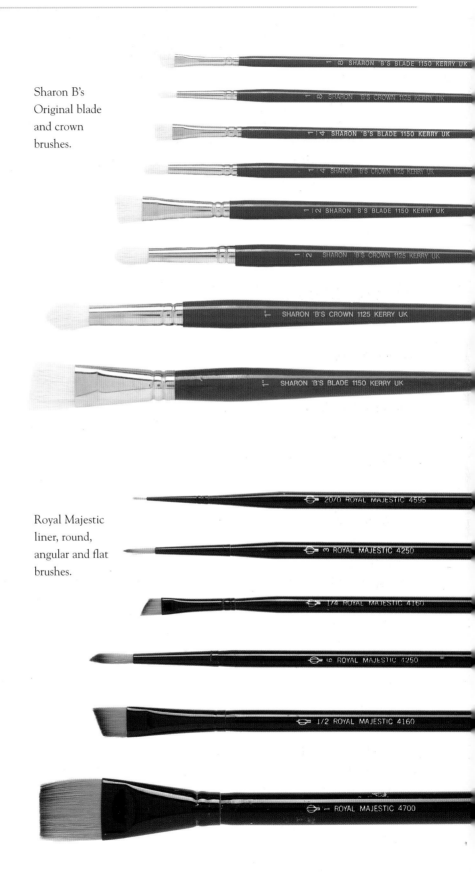

Sharon B's Original blade and crown brushes.

Royal Majestic liner, round, angular and flat brushes.

PAINTS AND OTHER PRODUCTS

I use DecoArt Americana acrylic paints because they have a consistency that is just right for my style of painting. The colors are perfect for landscapes because they are both opaque and transparent, which is important when building dimension and tone. Opaque colors are the "workhorses" that create overall coverage, while the transparent colors complete the final tone and dimension. The most common remark I hear is, "I love your colors!" This is a direct result of my choice of acrylic paints. You will notice that I have a favorite palette which provides the exact tone (cool, warm, light, dark) for the projects in this book.

I include DecoArt Multi-Purpose Sealer with the paints or use it alone to seal and prepare all surfaces before painting. I trust this medium because it will not make the surfaces too shiny or slick for the thin applications of paint I like to use. It properly seals wood, does not raise the grain and is excellent for all other surfaces. DecoArt DuraClear Satin Varnish is another favorite because it not only protects the surface, but also will not create a high shine that distorts my artwork. I also highly recommend DecoArt DecoMagic Brush Cleaner for removing acrylic paints from my Sharon B's natural bristle brushes as well as synthetic brushes.

I will use pale yellow mix throughout the book to basecoat and paint elements in the various projects. To create this mix combine Buttermilk + Yellow Ochre + DecoArt Multi-Purpose Sealer (2:1:1). Mix the ingredients well and store in a container.

Let's Talk: Helpful Hints

"Less is better than more." This is my motto for successful landscape painting. If you tried to paint as many flowers as you actually see in a flower bed, your eyes would be confused as to the variety. Each flower would become part of a color jumble, losing its individual definition. This also applies to tree leaves and branches, clouds and water ripples. Keep your landscapes open and allow the freedom to fill in later.

It is very important to make sure your brushes are properly loaded for every application. You can find loading instructions in the next chapter.

I often use a hair dryer to speed-dry my painting. A few words of caution: please use only the medium heat setting for two reasons. One, high heat will cause acrylic paint to lift, peel or craze. Two, you stand the chance of overheating flammable surfaces and burning yourself. Using the dryer on medium or low heat is safe and useful for drying washes, glazes and wet-on-wet applications. You can even use a hair dryer set on low heat to dry your brushes and open the bristles.

You will notice in the instructions that I often tell you to dampen your surface. This is important because without the damp surface the paint application will not look the same. It will become uncontrollable and will not allow you to place and blend the paint before it dries. It also allows you time to remove the application and start over if you do not like it. Always use clean water.

More Helpful Hints

"Wet-on-wet" is exactly what it implies: wet paint on top of wet under-paint. By using fresh paint that has not been thinned, you create an impressionistic style that resembles an oil painting. For example, I use wet-on-wet painting on foreground flowers and leaves to create a dimensional appearance by "melting" the colors. It is also a wonderful way to melt tints into wet clouds.

Another way to paint wet-on-wet is to first dampen the surface with clean water. The water allows the fresh paint to settle on the dried background painting without causing an unnatural appearance.

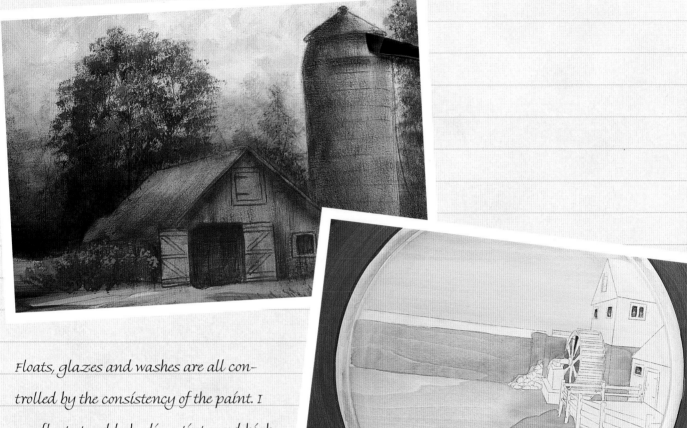

Floats, glazes and washes are all controlled by the consistency of the paint. I use floats to add shading, tints and highlights. You can use the paint full strength for a more opaque application or slightly thinned for a more transparent application. Although a few of the acrylic colors are produced as transparent colors, you will be able to better control paint with moisture on the surface. Painters call it a "float" because the moisture on the surface allows the color to float on the desired area. Washes and glazes are very transparent color applications, so the paint is thinned with even more water.

Floats, glazes and washes will be very free and fluid, so be sure to keep your project flat or the paint will drip and run. Do keep them thin because you want to see the dry under-painting through these different applications. Each technique is important for controlling color layering, which in turn creates dimension and interest.

Painting Terms and Techniques

CROWN BRUSH

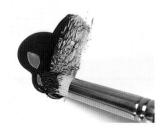

Loading the Crown Brush Hold the brush in the middle of the handle and slowly roll the bristles across the edge of the paint puddle. Make sure the bristles are fully loaded all the way to the ferrule.

Tipping Roll only the tip of your brush across the edge of the paint puddle. Less paint will be absorbed into the bristles, allowing for a lighter or a smaller application.

Tapping/Dabbing Load your brush and tap the excess paint off on the paper palette to open up the hair. Gently tap or dab your brush, creating a random pattern. You can use this technique for leaf clumps, distant trees and background bushes.

Scumbling Scribble paint over the surface in curving brushstrokes in both directions, creating a textural application. You can use this technique to create cloud formations.

Dry Brush/Dragging Lightly drag your dry brush across the paper, applying only trails of paint. This technique is perfect for old wood buildings and fences.

BLADE BRUSH

Tipping/Loading the High Corner of the Blade Brush
Hold the brush in the middle of the handle, push the high corner of the brush into the edge of the paint puddle and pull back.

Chisel-Edge Loading Place the full chisel (cut) edge of the brush into the edge of the paint puddle. Pull back and tap on the paper palette to open up the hair.

Tapping/Dabbing Create a random pattern using an up-and-down motion. You can use this technique for foreground leaf clumps, bushes and wildflowers.

Dry Brush/Dragging Lightly drag your dry brush across the paper, applying only trails of paint. You can use this technique for large wood buildings and water reflections.

Halo Brush

Loading the High Side of the Brush Drag a long line of paint onto the paper palette using a squeeze-top bottle. Hold the brush firmly by the handle and dab across the paint, loading the high side of the chisel edge.

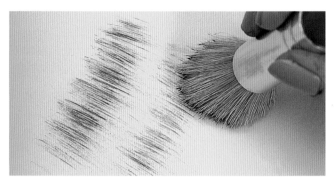

Short Strokes Load the high side of your brush, and lightly drag your dry brush. You can use this technique for short grasses.

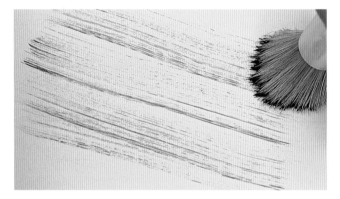

Long Strokes Use the same technique as with the short strokes, but extend your stroke farther. You will use this application to form the faux book pages on the Keepsake Box project (page 56).

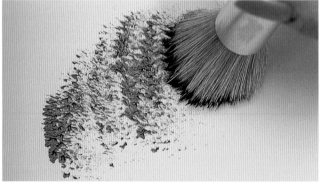

Tapping Load the high side of the brush halfway around the chisel edge of the circle shape. Tap the brush on the surface to form semicircular applications. This technique is perfect for fountain-shaped bushes.

Spattering Load the entire circular chisel edge of the brush with slightly thinned paint. Tap off the excess on the paper palette to open the hairs. Firmly grasp the ferrule and drag your thumb across the fully loaded chisel edge to create spatters of color.

Hint

If your paint is too thin it will create large, elongated spatters. For delicate applications, be sure the paint is not too thin. Test on a piece of paper for the proper effect and be sure to cover areas that you do not want spattered.

Side Loading Dampen the brush with clean water and blot on a paper towel. Then, drag the corner or high side of the brush across the edge of the paint.

Loading Very Thin Paint Fully load the brush with clean water and pull a small amount of paint from the edge of the puddle. Work the wet brush hair into the paint to make a very transparent color.

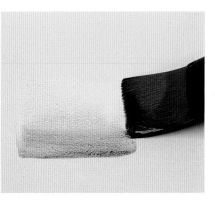

Blending Off Side load your brush and blend by walking the brush on the palette. Turn your brush over and repeat. The paint should bleed across the bristles but fade off to a clean opposite side. Test a stroke on paper before applying to your surface.

Float/Side-Load Stroke Side load the brush and blend off. Place the loaded side of your brush next to the area to be painted, and gently stroke in your color. You can use this technique to shade, tint and highlight painted elements. If the surface is dampened first, the stroke application will look softer.

Zigzag Stroke Side load and blend off your brush. Pull it back and forth across the paper in a zigzag motion. You can use this technique to create shadows on pathways, at the edge of flower beds and along water shorelines.

Glazing Load your brush with extremely thin paint, and gently stroke on the desired color. Be sure to keep your paint thin; this will ensure that your color appears transparent.

Hint

Glazing can always be repeated if it dries too light, but it is very hard to remove if it is too dark.

ROUND BRUSH

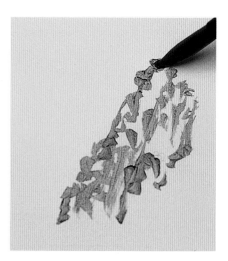

Loading the Round Brush Dampen the hair in clean water, blot on a paper towel, then work the paint into the hair from the edge of the paint puddle. Fully load the paint to the bottom of the ferrule.

Stutter Stroke Dampen the surface with clean water. Use a stutter motion to create random forms that bleed onto the surface. This is perfect for soft ripples on water.

Squiggle Stroke This technique is done in the same way as a stutter stroke but on a dry surface. It creates a more textural application.

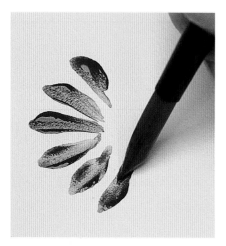

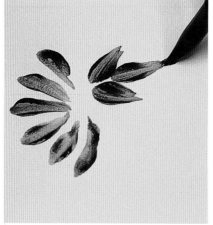

Hint
——
You will not have good control of the strokes if you have too much paint in the hair.

Outside One-Strokes Load the round brush half full, then start the stroke on the outside edge of the form and pull toward the center. The stroke is sometimes called a push-pull stroke because you push the brush down to form a head and pull up quickly for a tail. You can use these strokes to create flower petals.

Inside One-Strokes Load the round brush half full, and paint the same as the outside one-strokes, but start the stroke on the inside to create the form. You can use these strokes for long and short leaves off stems.

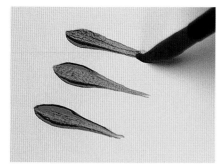 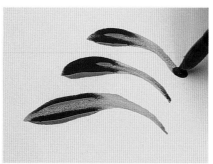

Hint

If the comma stroke is done quickly—or dragged—it will create a vareity of sizes, shapes and directions.

Tear-Drop Stroke Load the round brush half full and pull straight pressure-pull-lift strokes, forming a head with a graduated tail. This is sometimes called a pollywog shape. It is useful for petals and overstrokes on flowers.

Comma Stroke Load the round brush half full and paint as a tear-drop stroke, except with a curved tail. You can curve the tail in either direction according to the shape being formed. You can use these strokes on flowers or for fill-in designs on borders.

MOP AND LINER BRUSHES

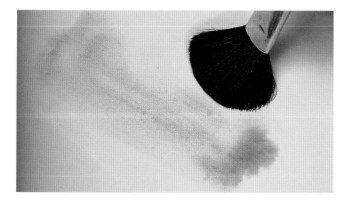 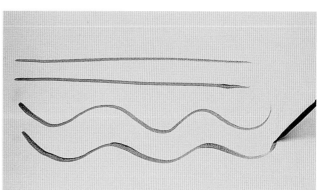

Blending Dampen a surface with clean water, and apply thinned paint using a flat/angular brush. Use a dry mop brush to soften and fade off the edges. This is very helpful when applying glazes.

Hint

For all brush techniques, it is best to use a paper palette and small amounts of paint.

Loading the Liner Brush Load the hair with clean water and drag it through the edge of the paint puddle. This will thin the paint while loading the hair. Make sure it is fully loaded to the ferrule. Check the flow of paint by testing a stroke on paper, then pull the loaded tip across the surface using light, even pressure. This allows the paint to flow out of the hair at a slower rate. For straight lines, pull the tip along a straight edge or pattern line. Form curved lines with a continuous flow of paint by moving the tip in an S pattern with light, even pressure. For longer straight or curved lines, use a long-hair script liner; for shorter linework, use a short-hair liner.

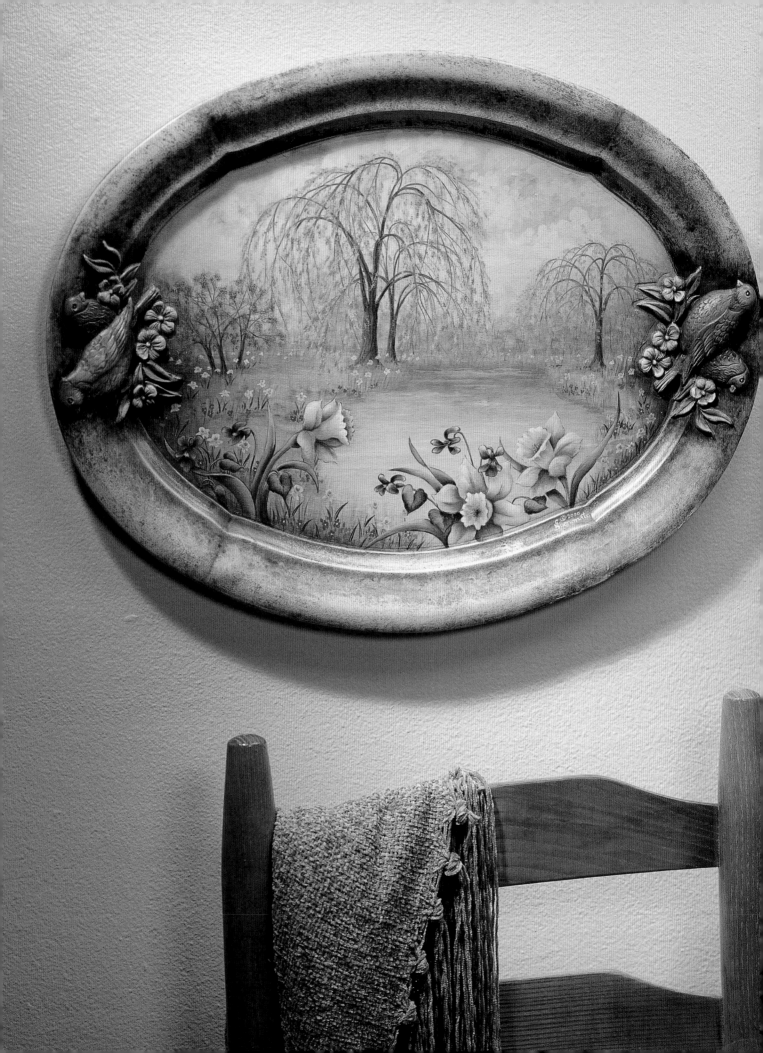

Eternal Spring

This first project consists of all the basic elements and is very important as a first step in painting acrylic landscapes. I will teach you how to paint skies, clouds, distant trees, midground trees, bushes, grasses, water, simple flower forms, and foreground flowers and leaves. I will also teach you how to provide a "frame" for your scenes with information on how to antique the border design. I think this project design would also look great without the large flower design and detailed border work. You could try painting it on something less fancy.

materials

Pale yellow mix =
Buttermilk + Yellow
Ochre + Multi-Purpose
Sealer (2:1:1)

Buttermilk

Yellow Ochre

Hi-Lite Flesh

Blue Mist

Pansy
Lavender

Lilac

Plum

Black Plum

Moon Yellow

Cadmium
Yellow

Raw Sienna

Sable Brown

Pumpkin

Cherry Red

Jade Green

Arbor Green

Plantation Pine

Silver Sage
Green

Soft Blue

Baby Blue

Victorian Blue

Graphite

Asphaltum

Surface
- oval bird tray from
 R & M What Knots

Brushes
- ³/s-inch (10mm) crown
- ¹/4-inch (6mm) blade
- ¹/4-inch (6mm), ³/s-inch (10mm)
 and 1-inch (25mm) angulars
- nos. 3, 5 and 8 rounds
- nos. 10/0 and 1 liners
- 2-inch (51mm) foam brush

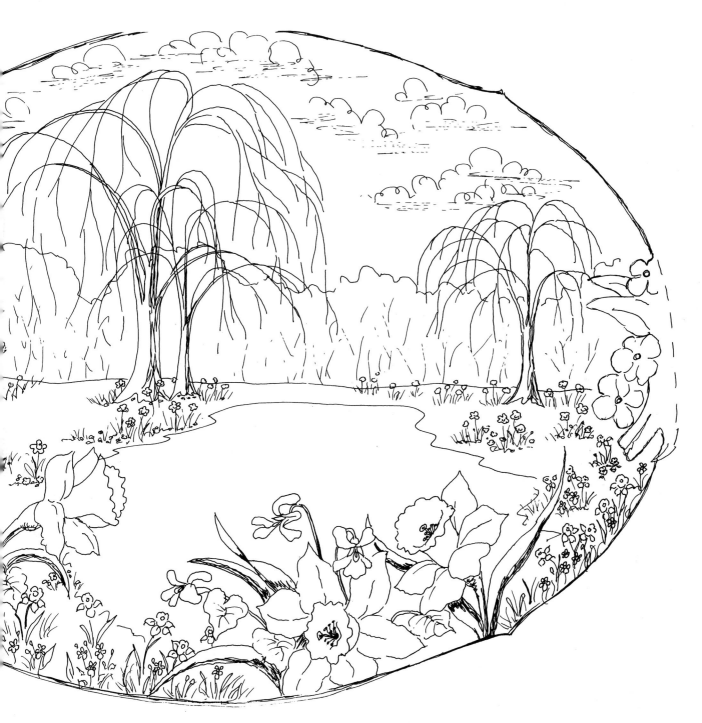

This pattern may be hand-traced or photocopied for personal use only. Reattach the two parts of the pattern, then enlarge at 167 percent to bring to full size.

Preparation

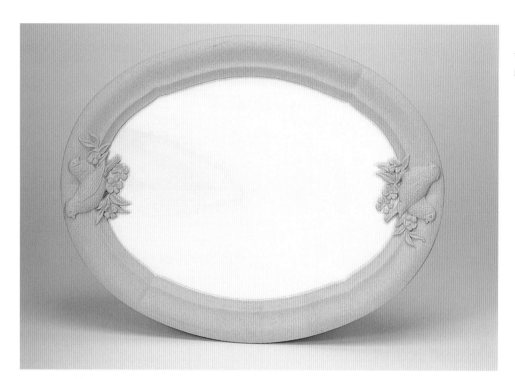

1 Lightly sand the surface with extrafine sandpaper and wipe clean.

2 Basecoat the entire rim with pale yellow mix. Basecoat the center area with Buttermilk + DecoArt Multi-Purpose Sealer (2:1) using the 2-inch (51mm) foam brush.

3 Tape the pattern to the surface, insert gray graphite paper and transfer just the horizon line and the shoreline using a stylus.

4 Moisten the surface with clean water using the 1-inch (25mm) flat brush. Wash in Blue Mist at the top.

5 Wash in pale yellow mix at the bottom in the same way. Wipe the brush and blend in the center.

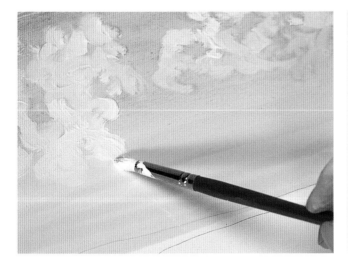

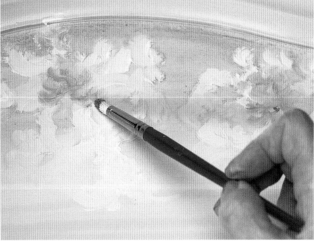

6 Scumble Hi-Lite Flesh cloud formations on the wet sky using the ⅜-inch (10mm) crown.

7 Tint the bottom of a few clouds by scumbling in Pansy Lavender with a tip load on the ⅜-inch (10mm) crown.

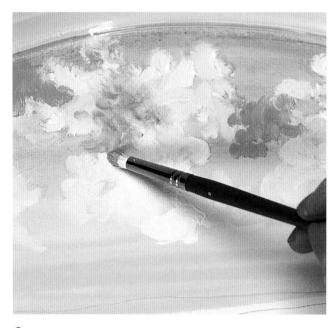

8 Separate the sky holes between the clouds by scumbling Blue Mist using the ⅜-inch (10mm) crown.

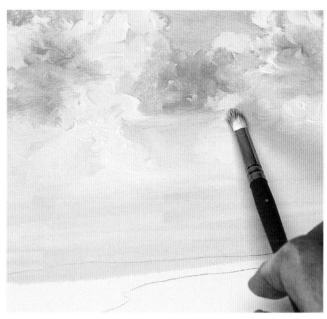

9 Wipe the crown and streak out the bottom of the clouds and sky holes.

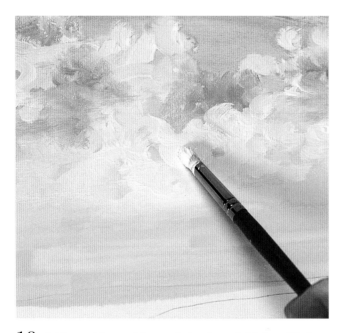

10 Add an additional layer of clouds with Hi-Lite Flesh.

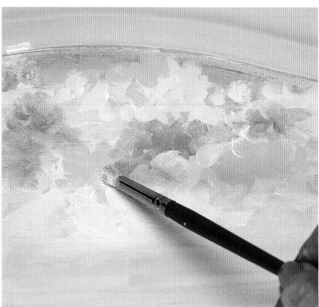

11 Tint a few clouds with a tip load of pale yellow mix on the ⅜-inch (10mm) crown.

Distant Trees and Pond

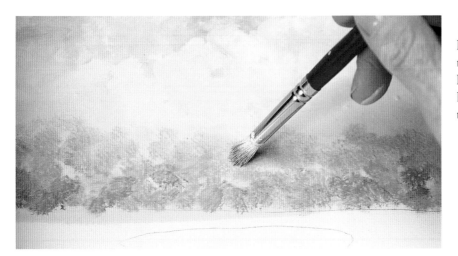

12 Moisten the surface and tap on Lilac to the top of the tree line using the ⅜-inch (10mm) crown. Add Pansy Lavender to the base of the horizon line and tap up to melt the colors together in the center. Let dry.

13 Add trunks and branches with Plum linework using the no. 1 liner.

Hint

Turn your work upside down and pull the trunks and branches toward you.

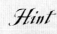

14 Moisten the pond and wash on Blue Mist along the top and pale yellow mix along the bottom. Scumble in Hi-Lite Flesh, and horizontally drag the 1-inch (25mm) flat brush to soften the cloud reflections.

Grass Area

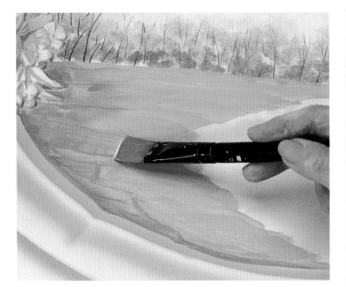

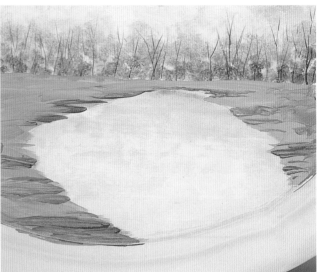

15 Wash on thinned Jade Green using the 1-inch (25mm) flat. Working wet-on-wet, begin shading on the left and pull the brush horizontally using Arbor Green.

16 Add Raw Sienna here and there along the pond edge for streaks of dirt. Paint the right grass area the same as described in step 15.

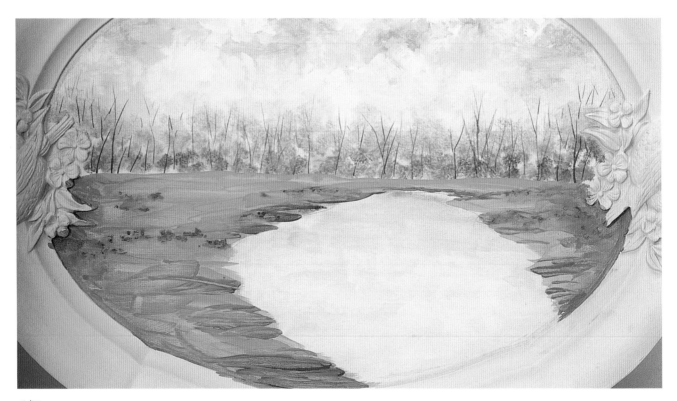

17 Trace on the pattern for the little flowers. Moisten and tap on the distant violets with Pansy Lavender using the no. 1 liner.

Willow Trees

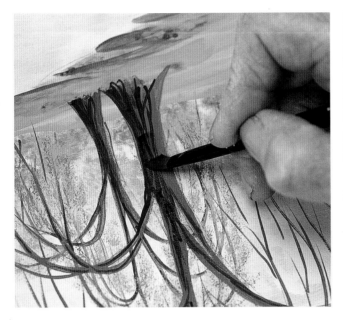

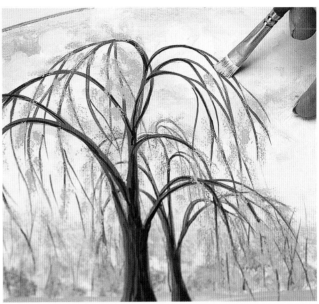

18 Transfer on the three willow trees. Paint the two smaller trees trunks and branches with Raw Sienna linework. Paint the largest tree the same, except use Sable Brown for the trunks and branches. With Asphaltum, detail all the willow trees, then side-load float shading using the ¼-inch (6mm) angular.

19 Load the chisel edge of the ¼-inch (6mm) blade with a scant amount of Jade Green, and dab on delicate leaves.

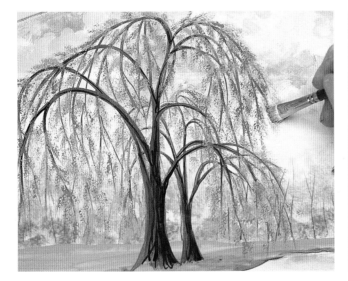

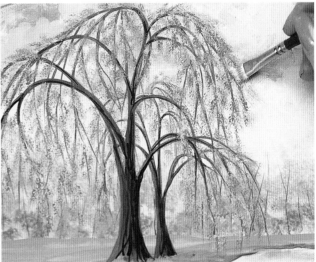

20 Add a scant amount of Arbor Green in the same way. Keep the right side darker by using more Arbor Green on the right and less on the left.

21 Add Moon Yellow highlights in the same way.

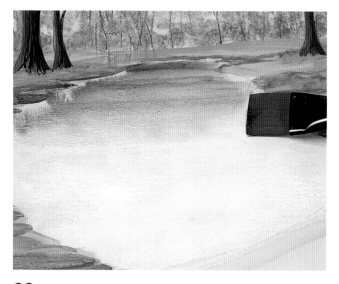

22 Dampen the pond and side-load float Pansy Lavender across the top using the 1-inch (25mm) flat. Let dry.

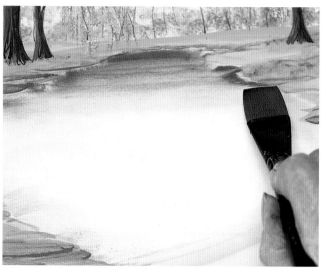

23 Moisten the surface and add Victorian Blue with a zigzag side load to shade the edges of the pond. Let dry.

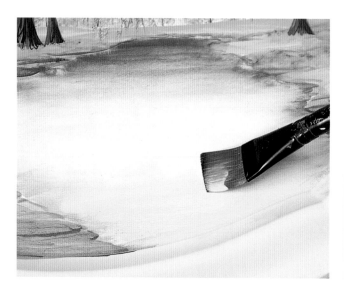

24 Moisten the surface and wash the bottom with Cadmium Yellow. Let dry.

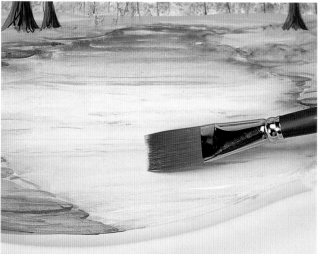

25 Dampen the surface with clean water and paint horizontal ripples with pale yellow mix and Blue Mist using the no. 3 round brush. Pull the 1-inch (25mm) flat horizontally to soften the colors. Let dry.

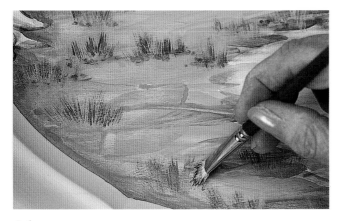

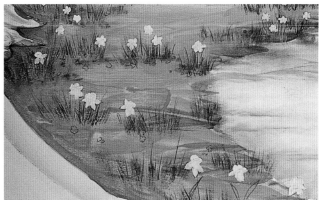

26 Drybrush the grass area using the chisel edge of the ¼-inch (6mm) blade with Plantation Pine, pulling up and out. Accent in the same way using Jade Green. Detail the areas with a few Plantation Pine linework blades toward the bottom of the tray using the no. 10/0 liner.

27 Transfer the small daffodils and violets using gray graphite paper and a stylus. Paint all the daffodils using inside one-strokes, Moon Yellow and the no. 1 liner.

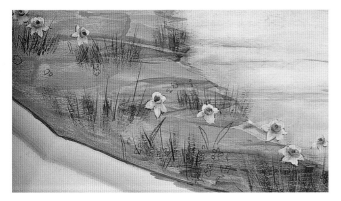

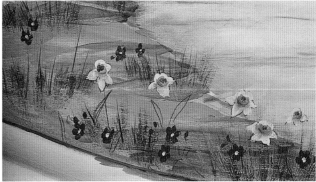

28 Shade the daffodil cups with a side-load float of Pumpkin using the ¼-inch (6mm) angular. Create the centers with smaller floats of Raw Sienna and linework using the no. 10/0 liner. Shade across the tops of the petals with a side-load float of Pumpkin.

29 Create the violets with outside one-strokes of Pansy Lavender. Dot the centers with Moon Yellow.

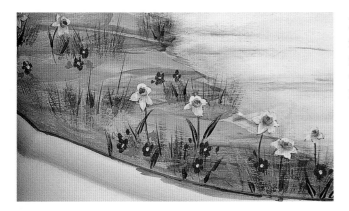

30 Add stems and inside one-stroke leaves to the daffodils with Plantation Pine using the no. 1 liner. Around the violets sprinkle in a few smaller inside one-stroke leaves with Arbor Green. Add a center vein on the larger daffodil leaves with Jade Green and the no. 10/0 liner.

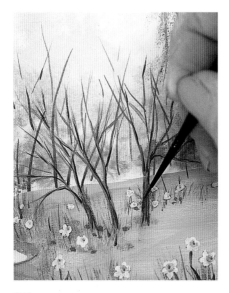

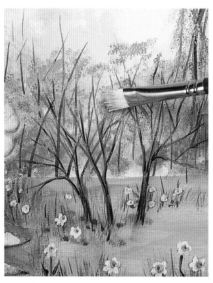

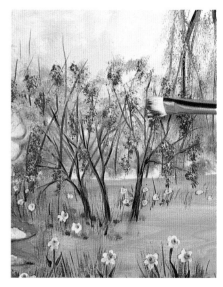

31 Transfer the lilac bush with your gray graphite paper and a stylus. Paint the trunks and branches Sable Brown with the no. 10/0 liner. Then detail and shade with Asphaltum.

32 Tap on leaves using a tip load of Arbor Green on the ¼-inch (6mm) blade, then add Jade to highlight.

33 Form lilac clumps using Pansy Lavender in the same way as the leaves. Add Lilac to highlight the top of the clumps.

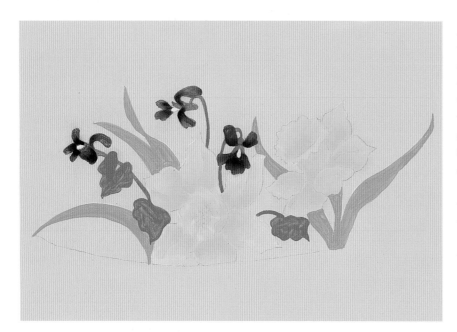

34 Transfer on the large daffodils, violets and leaves. Basecoat these elements with one coat of Buttermilk using the round brushes. Next, basecoat the daffodils with Moon Yellow and the violets with Pansy Lavender. Paint the daffodil leaves and stems with Jade Green; paint the violet leaves and stems with Arbor Green.

Dampen the daffodils, then shade them with a side-load float of Cadmium Yellow applied with the ⅜-inch (10mm) angular. Shade the violets with Black Plum side loaded on the ¼-inch (6mm) angular.

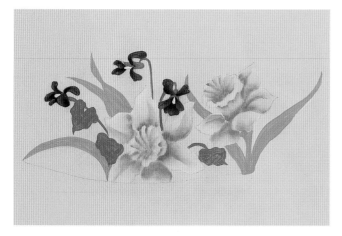

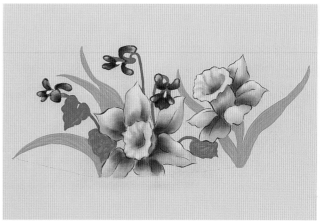

35 Add a second shading to the daffodils with Pumpkin, and tint the edges of the violet petals with Pumpkin.

36 Shade the daffodils with Raw Sienna, applied the same way as in the previous step, but using less color.

Dampen the surface and tint the shaded daffodil areas with Plum. Tint the edges of the petals and the throats with Jade Green using the ¼-inch (6mm) angular. Tint the tips of the violet petals with Lilac.

Add a cool tint of Silver Sage Green where the daffodil petals overlap and on a few tips. Highlight the ruffled area of the centers and the tops of a few petals with Hi-Lite Flesh. Detail with Plum linework.

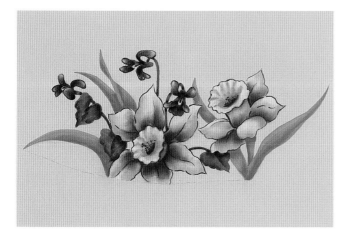

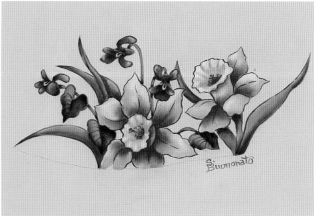

37 Create the daffodil stamens with Jade Green, and detail the pistils with Plum linework. Paint the violet centers with Cadmium Yellow and a dash of Cherry Red.

Shade the daffodil leaves and stems with Arbor Green. Shade the violet leaves and stems with Plantation Pine.

38 Add a second layer of shading to the daffodil stems with Plantation Pine. Highlight the violet leaves with Jade Green.

Tint the shaded areas with Plum and tint along a few edges with Pumpkin. Add Black Plum linework to the darkest areas of the violet leaves.

Highlight the tops of a few daffodil leaves with Silver Sage Green, then add touches of Cadmium Yellow to warm. Detail the veins, stems and edges of the leaves with Plantation Pine linework.

Rim and Bluebirds

39 Basecoat the large rim section with Moon Yellow and the smaller rim with Silver Sage Green. Basecoat the bluebirds with Baby Blue and Moon Yellow. Paint their eyes with Graphite on the no. 1 liner. Basecoat the blossoms with Soft Blue petals and Moon Yellow centers, and basecoat the leaves with Jade Green. Use the no. 3 and no. 5 round brushes for basecoating, as they will help you apply paint in the tight, recessed areas.

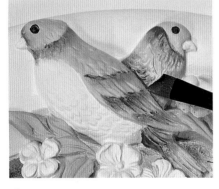

40 Dampen the bluebirds and side load Victorian Blue on the ⅜-inch (10mm) angular. Shade under the heads, next to the beaks, between the wing feather sections, on top of the tail and between the two bodies on the back bird. Let dry.

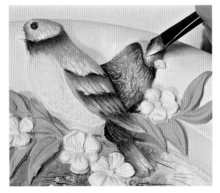

41 Moisten the birds, then shade again with Black Plum in the same areas. Highlight the bottom of the cheeks, the top of each wing feather section and the tips of the wing and tail with a side load of Lilac using a ⅜-inch (10mm) angular.

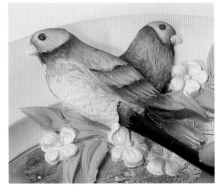

42 Tint with a float of Pansy Lavender in the same way on the top of the heads, along the front of the body next to the tummy, on the back of the necks and on the left side of the tail. First shade their tummies with Cadmium Yellow. Let dry, then shade again with less Pumpkin.

Blossoms

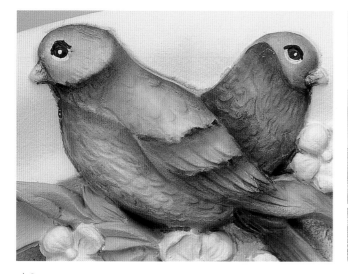

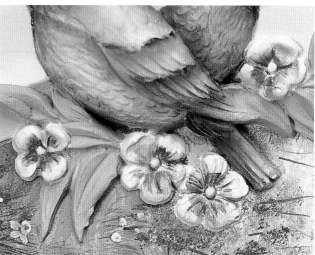

43 Use Raw Sienna and the ⅜-inch (10mm) angular for the third shading color on the tummies and the base of the beaks. Float a tint of Plum to the base of their tummies. With the no. 10/0 liner, paint the top eye line in Black Plum and the underline in Lilac. Paint the highlight dot to the front of each eye with Lilac.

44 Side-load float Baby Blue around the raised centers of the blossom petals using the ¼-inch (6mm) angular. Darken the shading using slightly less Victorian Blue on the same brush.

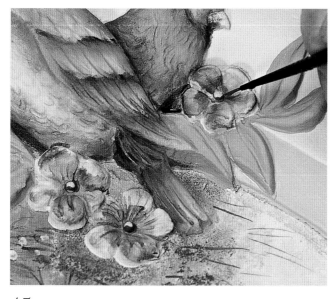

45 Float a tint of Pansy Lavender on the outside edges of the petals in the same way. Shade the centers with a wash of thinned Raw Sienna on the no. 3 round. Then, wipe the paint off the surface with a paper towel, leaving a highlight only on the centers. Accent with a single stroke of Cherry Red at the base of each center using the no. 10/0 liner.

46 Shade the leaves first with Arbor Green at the base using a side-loaded ⅜-inch (10mm) angular. Next, use less Plantation Pine to darken the shading. Highlight the tips of each leaf with a float of Silver Sage Green.

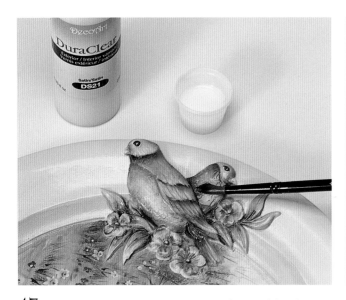

47 Clean any smudges with the rim colors and let dry. Now, basecoat the back of the tray with Moon Yellow and allow to dry. Apply one even coat of DecoArt DuraClear Varnish to all surfaces before antiquing. Use the round brushes for the raised designs and the 1-inch (25mm) flat brush for the smooth surfaces.

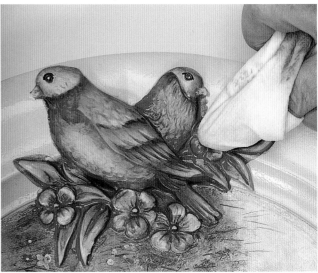

48 Wash over the bluebirds, flowers and leaves with thinned Raw Sienna using the no. 8 round brush. Wipe off the top with a damp, clean paper towel or lint-free cloth wrapped around your finger. Allow the wash color to remain in the recesses. Let dry.

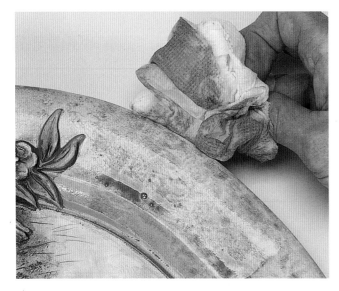

49 Now do the same to the smooth rim area—glazing only a small area at a time—using the 1-inch (25mm) flat. Dab off the Raw Sienna wash with a damp, crumpled paper towel or lint-free cloth. Leave a mottled appearance on the surface. Let dry.

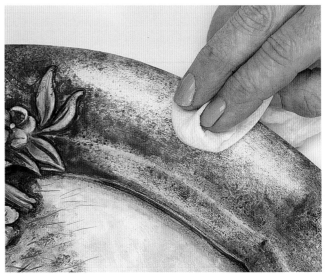

50 Repeat the process with Asphaltum, and allow it to almost dry. Gently rub off some of the color on the center areas of the birds, flowers, leaves and rim using the damp cloth or towel. This will form highlights, leaving the Asphaltum in the recessed areas and grooves of the rim and raised design. Repeat this process for the back of the tray, making the outside edge darker. Let dry.

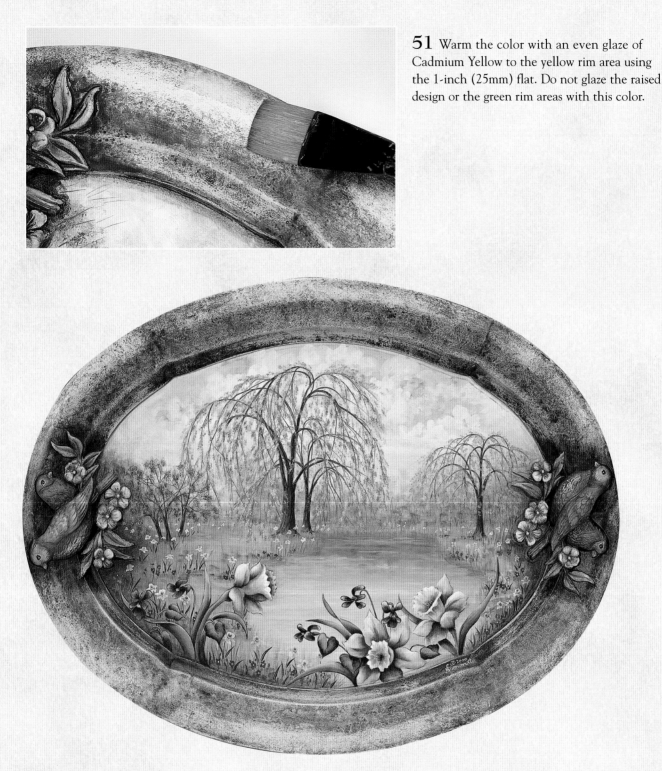

51 Warm the color with an even glaze of Cadmium Yellow to the yellow rim area using the 1-inch (25mm) flat. Do not glaze the raised design or the green rim areas with this color.

52 Let dry and apply several coats of varnish using the 1-inch (25mm) flat, allowing proper drying time between coats. For an excellent finish, I apply the varnish using a flat brush rather than a foam brush, which can produce ugly air bubbles.

If you decide to paint this on a surface without a rim design, be sure to paint the outside edges and other areas with colors from the palette. And remember to always paint every part of the surface for a more professional look.

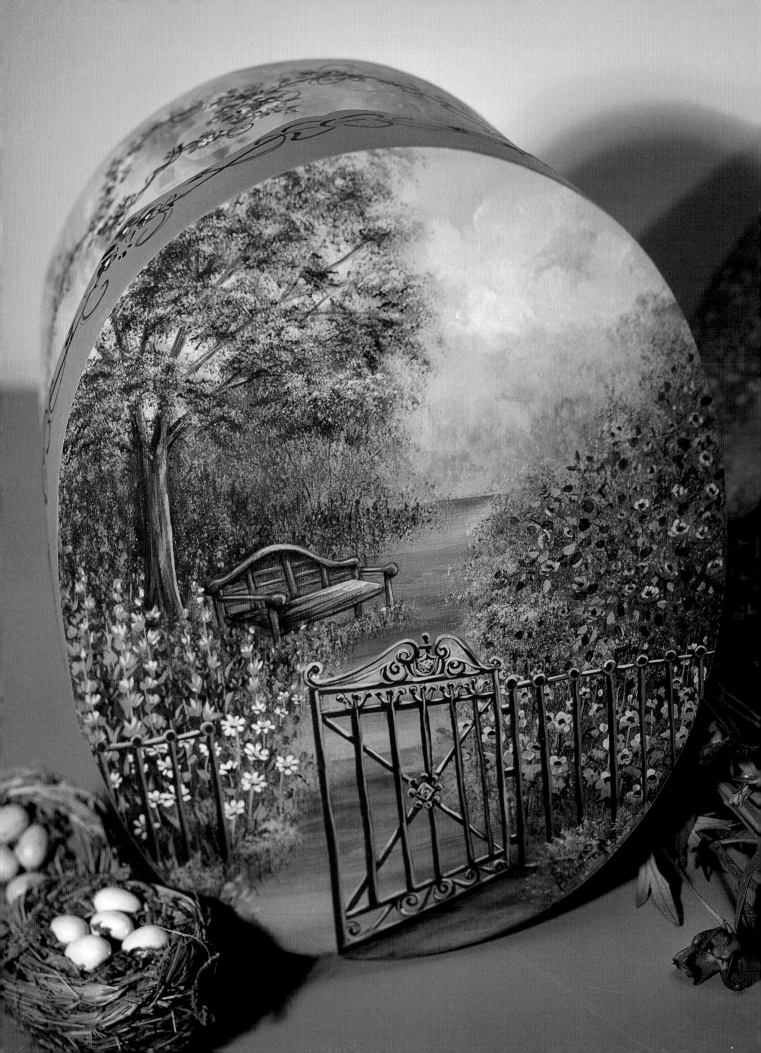

Victorian Garden Gate

Victorian Garden Gate is the next step in learning additional landscape elements. This colorful summer scene is painted on a large nesting box and includes a leafed tree, a small structure, five different flower forms, a foreground iron fence and gate, and green shrubs. The box sides and base have a repeating floral design created with a soft "watercolor" background technique. This nesting box is sold with a smaller companion. You can repeat the flower forms on the smaller box, or you can use the lessons you have learned and create your own design. I am sure you will enjoy painting these garden boxes!

materials

Pale Yellow mix =
Buttermilk +
Yellow Ochre +
Multi-Purpose
Sealer (2:1:1)

Buttermilk

Yellow Ochre

Hi-Lite Flesh

Blue Mist

Pansy
Lavender

Antique Mauve

Plum

Black Plum

Moon Yellow

Cadmium
Yellow

Pumpkin

Cherry Red

Bright pink mix =
Cherry Red +
Hi-Lite Flesh (1:1)

Light pink mix =
Bright pink mix +
Hi-Lite Flesh (1:1)

Jade Green

Antique Green

Yellow-green mix =
Cadmium Yellow +
Plantation Pine (1:1)

Plantation Pine

Evergreen

Blue/Grey
Mist

Baby Blue

Sapphire

Williamsburg
Blue

Midnite Blue

Sable Brown

Asphaltum

Graphite

Surface
· oval nesting box
 with fancy-edge lids
 from Valhalla
 Designs

Brushes
· ¼-inch (6mm) and
 ⅜-inch (10mm)
 blades
· ¼-inch (6mm)
 crown
· 1-inch (25mm) flat
· ½-inch (12mm)
 angular
· no. 3 round
· nos. 10/0 and 1
 liners and no. 1
 script liner
· 1-inch (25mm)
 foam brush

These patterns may be hand-traced or photocopied for personal use only. Enlarge both patterns at 200 percent to bring to full size. The top pattern is for the rim of the lid; the bottom pattern is for the sides of the box.

This pattern may be hand-traced or photocopied
for personal use only. Enlarge at 125 percent to
bring to full size.

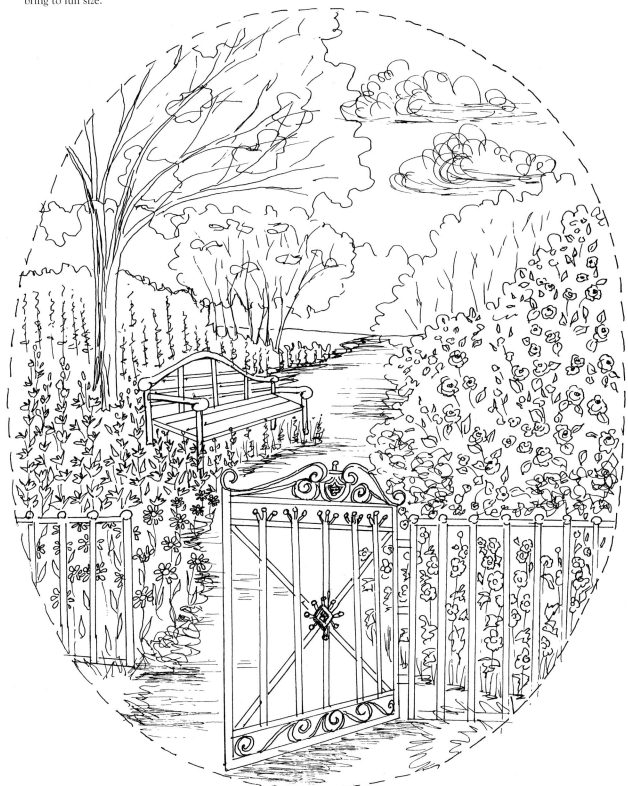

Background, Trees and Path

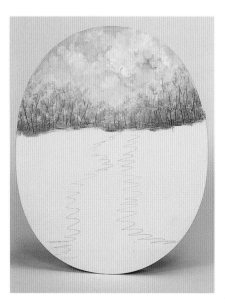

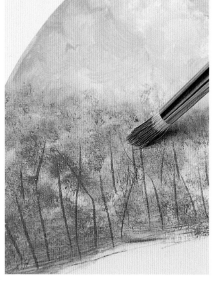

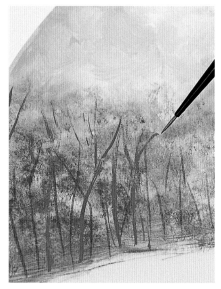

1 Basecoat the box with two coats of pale yellow mix. Sand between each coat and wipe. Transfer only the horizon line and the pathway. Paint the sky, clouds and distant trees the same as you did in the first project, but use the ¼-inch (6mm) crown.

2 Dampen the surface and form the trees by dabbing Antique Green with the ¼-inch (6mm) crown. Let dry.

3 Detail the trees with Sable Brown linework branches and trunks using the no. 10/0 liner.

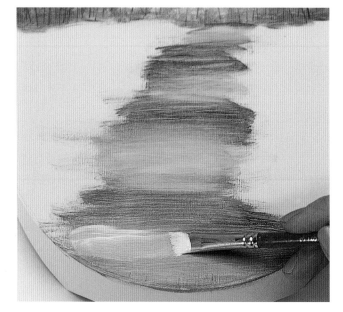

4 Form the pathway with the ⅜-inch (10mm) blade fully loaded with Antique Green. While still wet, horizontally streak on Plantation Pine for shadows and Moon Yellow for sunlight.

5 Add Asphaltum in the shadow areas for the dirt. Here I've turned the surface to easily paint the strokes. Let dry.

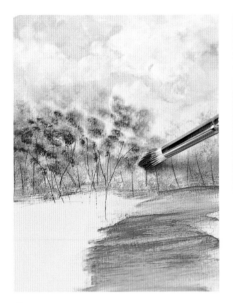

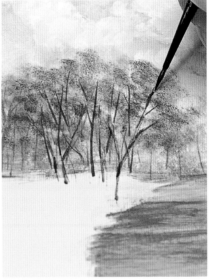

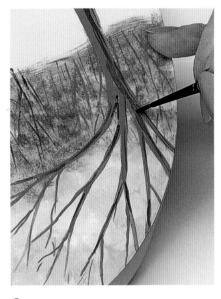

6 Trace on the lavender trees with gray graphite paper and a stylus. Dampen the surface and tap on Pansy Lavender for delicate foliage with the ¼-inch (6mm) crown. Darken the inside areas with Plum. Let dry.

7 Add trunks and branches with Asphaltum linework using the no. 1 liner.

8 Trace on the large tree. Paint the trunk and branches Sable Brown using the no. 3 round and no. 1 liner brushes. Paint Asphaltum shading on the left using the no. 1 liner. Remember that if you turn the tree upside down, the shading will reverse.

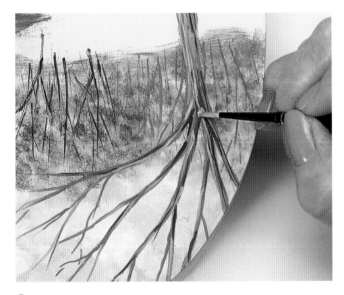

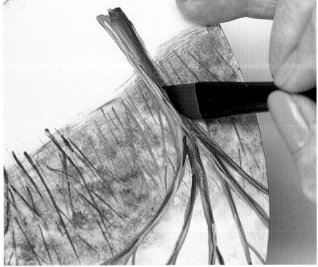

9 Highlight with Moon Yellow on the right in the same way. Tint the center trunk area Pumpkin. Let dry.

10 Float Black Plum to the left of the trunk and the larger branches using the ½-inch (12mm) angular.

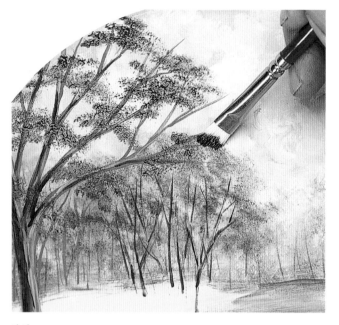

11 Form the first layer of the leaf clumps with Plantation Pine using the chisel edge of the ¼-inch (6mm) blade.

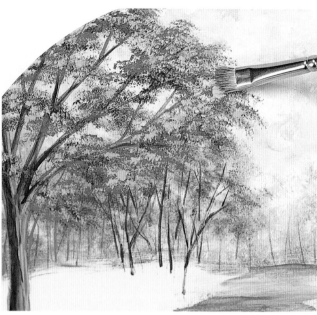

12 Add Antique Green with the chisel edge. Next, highlight with Jade Green using the tip of the blade.

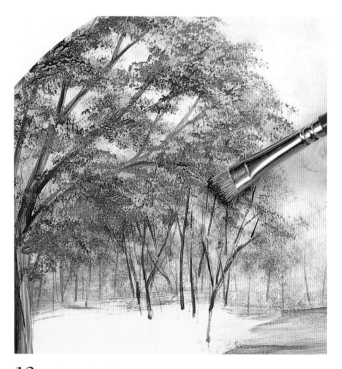

13 Darken the clumps at the base with Evergreen using the chisel edge of the blade.

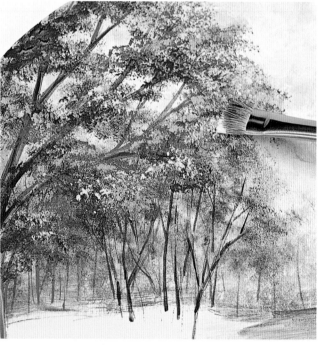

14 Add Moon Yellow to the right side of the leaf clumps using the tip of the ¼-inch (6mm) blade. Make sure that the sky holes remain visible between the leaf clumps and that they show branches.

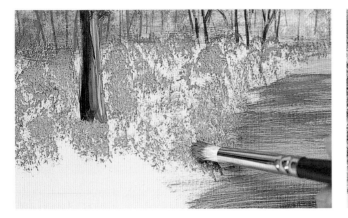

15 Tap on a delicate background for the gladiolas using Antique Green and the ¼-inch (6mm) crown.

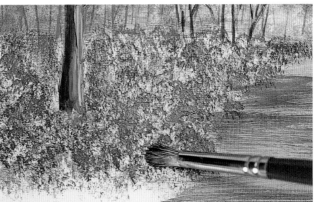

16 Add Plantation Pine in the same way.

17 Paint the distant flowers Cherry Red using the chisel edge of the ¼-inch (6mm) blade.

18 Add Pumpkin using the same method as shown in step 17. After you paint the bench, place very small gladiolas at the base in the same way. Let dry.

19 Glaze a thin wash of Plantation Pine over the gladiolas to darken. Side-load float Plantation Pine over the large tree on the left edge using the 1-inch (25mm) flat.

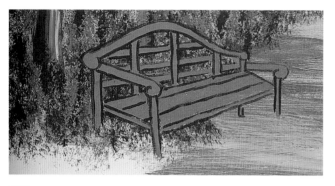

20 Trace on the bench with white graphite paper, a ruler and a stylus. Basecoat the bench with Sable Brown using the no. 3 round, and detail with Asphaltum using the no. 1 liner.

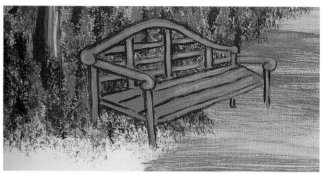

21 Tint the following areas with Pumpkin: the center of the seat, the vertical and horizontal braces, the top of the back and the arms. Use the no. 1 liner.

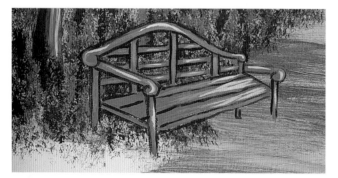

22 Add Moon Yellow on the right side of the seat and in the center of all the Pumpkin areas.

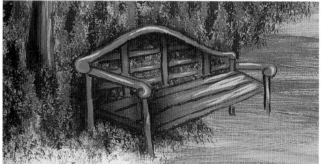

23 Shade with a float of Black Plum to the right side of the two left legs and under the curved top of the back. Use the ½-inch (12mm) angular. Also, float shading in the same way on the outside edge of the bench, on top of the gladiolas. Do not shade the right side of the bench that touches the pathway.

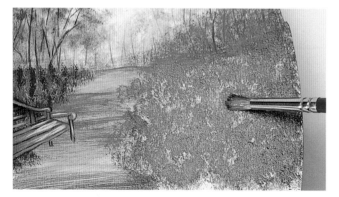

24 Tap on Antique Green with the ¼-inch (6mm) crown to form the rosebush.

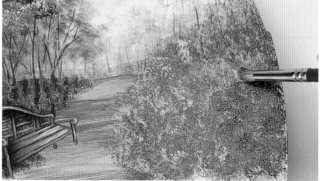

25 Apply Plantation Pine in the same way to shade the base of the bush. Add Jade Green highlights to the top and the left in the same way. Let dry.

Left Flower Bed

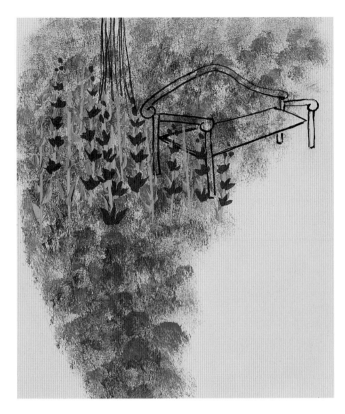

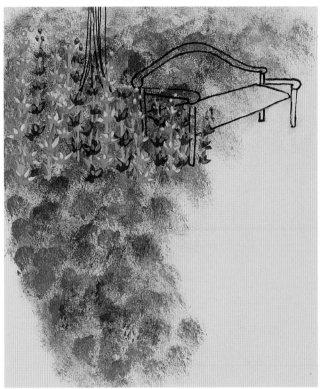

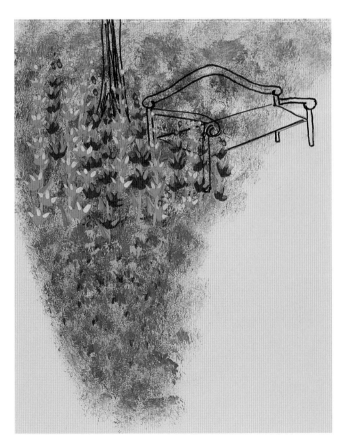

26 (**Above left**) To make it easier to see the flower beds, I've painted them here without the bench and background. Trace on gladiolas using white graphite paper and a stylus. With the no. 1 liner brush, paint the stems Jade Green and add inside one-stroke leaves with Jade Green tipped with Evergreen. To paint the flowers, load the no. 3 round with Cherry Red. Start each flower at the base of the stems and pull three inside one-strokes.

27 (**Above right**) Paint the Pumpkin flowers in the same way as the red flowers. Paint smaller Moon Yellow over-strokes using the no. 10/0 liner on the orange flowers, and do the same with Pumpkin on the red flowers.

28 (**Left**) Delicately tap on Sapphire for the blue filler flowers using the ¼-inch (6mm) crown. Add Baby Blue highlights and Midnite Blue shadows in the same way.

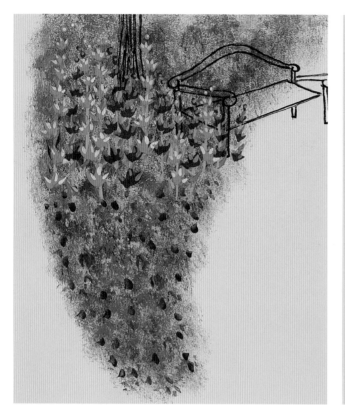

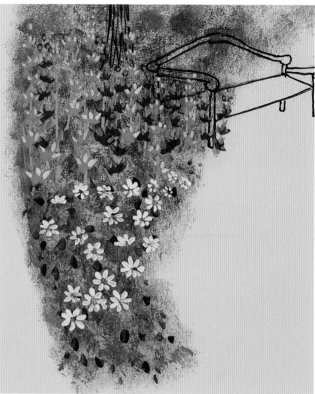

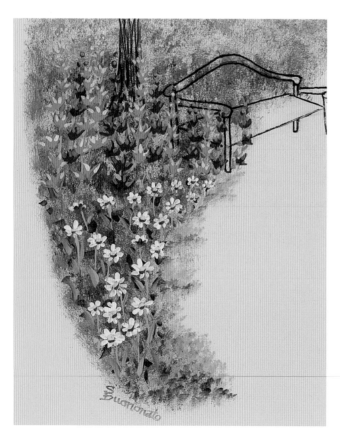

29 **(Above left)** Sprinkle in some tiny one-stroke leaves with Plantation Pine using the no. 1 liner.

30 **(Above right)** Trace on the daisies using white graphite paper and a stylus. Paint the tiny teardrop stroke petals using Hi-Lite Flesh and the no. 10/0 liner.

31 **(Left)** Add Cadmium Yellow centers and Jade Green stems. Create the leaves with Evergreen tipped with Jade Green and inside one-strokes using the no. 1 liner. Add a Cherry Red dash at the base of each center with the no. 10/0 liner.

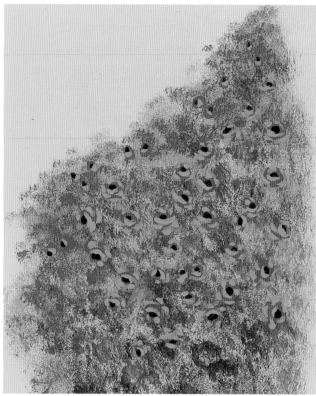

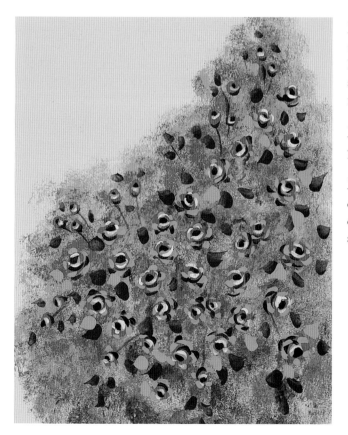

32 (Above left) Tap the bright pink mix on the bush for the distant roses using the tip of the ¼-inch (6mm) blade. Leave plenty of green showing between this application, and keep it delicate. For the large roses and buds, use this mix and the no. 1 liner.

33 (Above right) Add Black Plum throats and overstroke petals with the light pink mix using the no. 10/0 liner.

34 (Left) Add a few tiny Black Plum overstrokes at the base of each rose and a Hi-Lite Flesh overstroke across the base of each throat. Add small Evergreen inside one-stroke leaves around the roses. Then mix in a few Jade Green leaves.

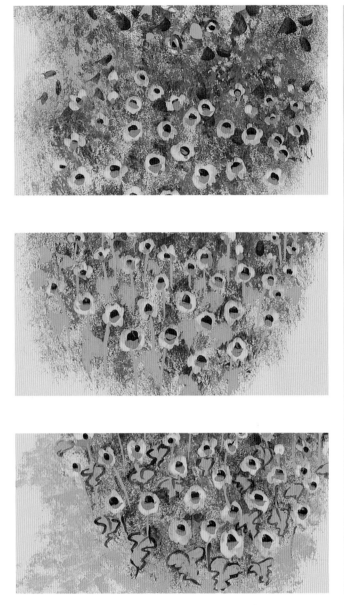

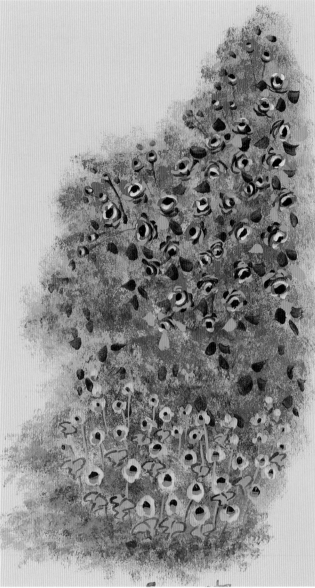

35 (**Top Left**) Paint the blue filler flowers at the base of the rosebush as previously instructed. Let dry. Trace on the nasturtiums on top of the blue filler flowers using white graphite paper and a stylus. Paint each flower with Cadmium Yellow dot petals, then add wet-on-wet Pumpkin overstrokes to the bottom petals using the no. 3 round. Add Asphaltum centers with a Pumpkin dash at the base with the no. 1 liner.

36 (**Middle Left**) Paint Jade Green stems and heart-shaped leaves using the no. 1 liner and head-to-head comma strokes.

37 (**Bottom Left**) Highlight the leaves using the yellow-green mix, then detail the outside edges with Asphaltum using the no. 10/0 liner.

The sedum is located at the base of the daisies on the left and by the nasturtiums on the right. Paint delicate Jade Green sedum using the tip of the ¼-inch (6mm) blade.

38 (**Above**) Add Plantation Pine to the base of the sedum and highlight the top with the yellow-green mix in the same way. The sedum should follow the pathway and spill over the edges and the bottom of the flowers.

Fence and Gate

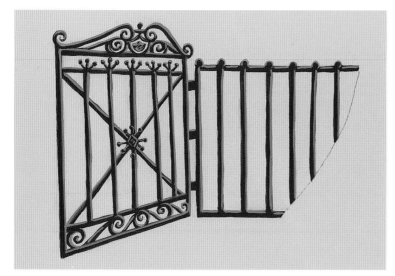

39 To make it easier to see how to paint the fence and gate, I've painted it here without the background path and flowers. Carefully transfer on the pattern with gray graphite paper, a stylus and a clear plastic ruler. Base the fence and gate with Graphite using the no. 1 liner. Add Blue/Grey Mist to the right side and to the top of all the structural work with the no. 10/0 liner.

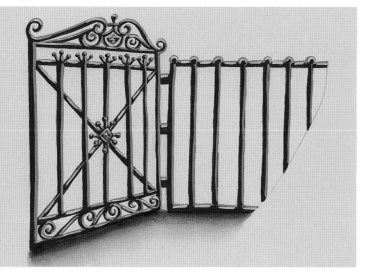

40 Add Moon Yellow highlights to the center areas of all the gray linework. Anchor the base of the fence and the gate with a side-load float of Black Plum on the 1-inch (25mm) angular.

41 Load the lower end of the ⅜-inch (10mm) blade with a combination of Antique Green and Evergreen; load Jade Green on the high end. Tap to blend on the palette and work in a fan shape with the Jade Green facing out. Continue to load your blade and paint in overlapping applications to finish the shrub. Reinforce the shadows under the gate and fence with a second float of Black Plum. You can drybrush sunshine on the pathway by horizontally dragging a small amount of Moon Yellow on the tip of the ¼-inch (6mm) blade.

42 Dampen the box base and dab on Moon Yellow with the 1-inch (25mm) flat. Allow it to drip so it can form blotches and run marks.

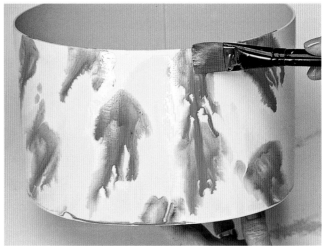

43 While still wet, dab Antique Mauve in the same way between the yellow application.

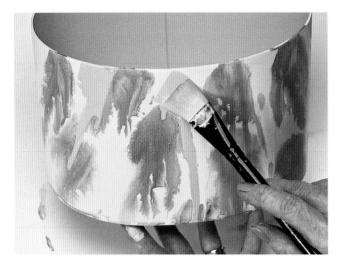

44 Apply Jade Green in the same way. Try to overlap with the yellow and mauve applications.

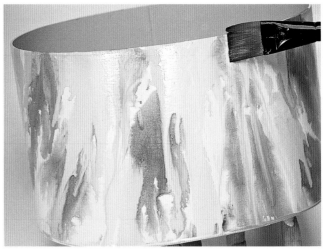

45 Dab on additional clean water to facilitate more runs and drips. This background looks good on the bottom and the inside of the box.

Lid Rim

46 Basecoat the lid rim with Williamsburg Blue using the 1-inch (25mm) foam brush. Transfer the pattern with gray graphite paper and a stylus or freehand on the design. Stroke Midnite Blue bows in the "bump" areas of the scalloped edge using a no. 1 script liner. Paint the ties, following the scalloped edge away from each side of the bows toward the "points." Detail the outside edges with Williamsburg Blue using the no. 10/0 liner. In the point areas, paint three forget-me-nots with five dot petals using Sapphire tipped with Midnite Blue on the no. 3 round.

47 While still wet, add Sapphire tipped with Baby Blue to highlight the top petals. Dry, then add Moon Yellow dot centers and dry again.

48 Add a dash at the base of each center with Cherry Red and the no. 10/0 liner. Paint the leaves with short inside one-strokes of Plantation Pine tipped with Jade Green. Use the no. 1 liner.

49 Add filler commas, teardrop strokes and vines using Plantation Pine and the no. 10/0 liner.

50 After the watercolor technique background has dried, transfer on the pattern with gray graphite paper and a stylus. Paint the bows using Williamsburg Blue in the same way as the lid design. Use Moon Yellow and Midnite Blue to outline and detail. Form the heart-shaped grapevines using Sable Brown linework with the no. 1 script liner, then add Asphaltum detailing with the no. 10/0 liner. Start painting the florals with the forget-me-nots as previously instructed.

Next paint the roses using the previously described technique. Place Pansy Lavender filler flowers using the tip of the ¼-inch (6mm) crown. Add Plum to shade the base area.

51 Now paint the daisies as instructed beginning in step 30 and the nasturtiums as instructed in step 35.

52 Add inside one-stroke leaves using Plantation Pine tipped with Jade Green. Paint Plantation Pine vines and comma strokes to fill the design using the no. 10/0 liner.

53 The repeated designs and colors on all the surfaces of this project create visual harmony. This is very important in painting successful decorative landscapes. Remember to paint the inside and bottom of the box with either the watercolor technique or one of the palette colors. Apply several coats of varnish to all surfaces for proper protection.

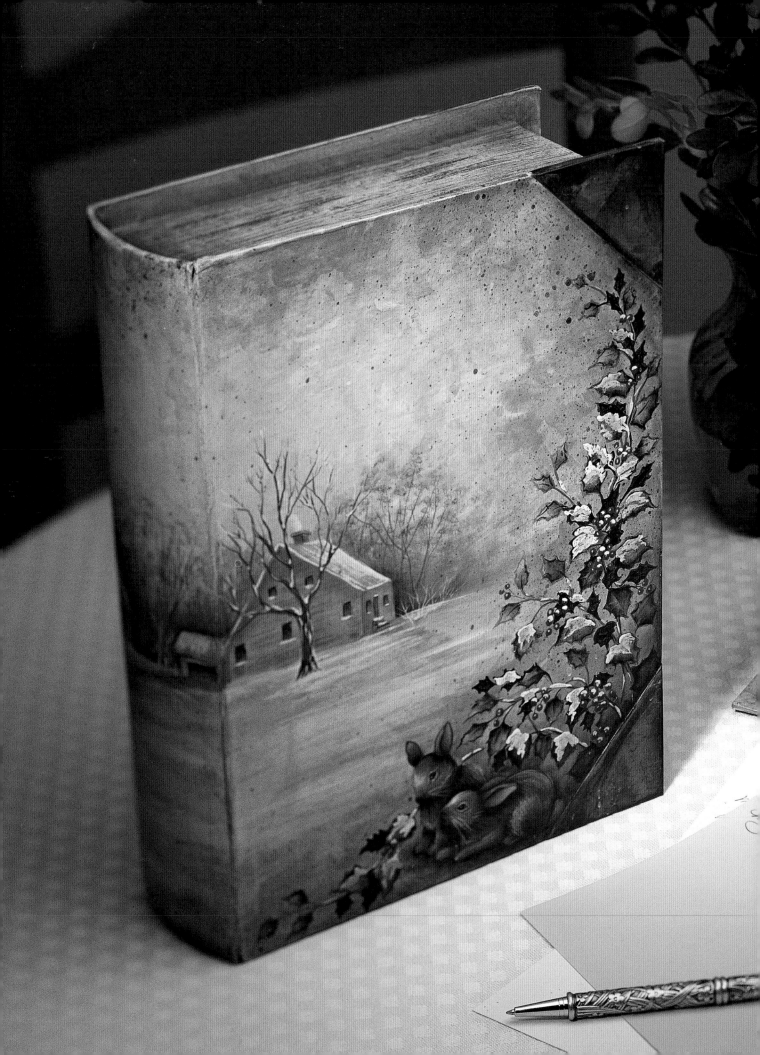

Project Three

Keepsake Box

The Keepsake Box design is painted on a papier-mâché book box with rusty tin corners. The project includes important information for painting this style of snow scene. You will notice that the background treatment is very different from what was previously taught. It requires a loose touch and faith in my instructions! The addition of several buildings will teach you how to create proper dimension, and the foreground holly, berries and bunnies provide a warm finish to a cool winter scene. This keepsake box is part of a set of four. On the other boxes, I suggest painting a singular structure such as a wishing well or another house. Or, you could adjust the size of the pattern to paint one of the bunnies with the holly-and-berry design.

materials

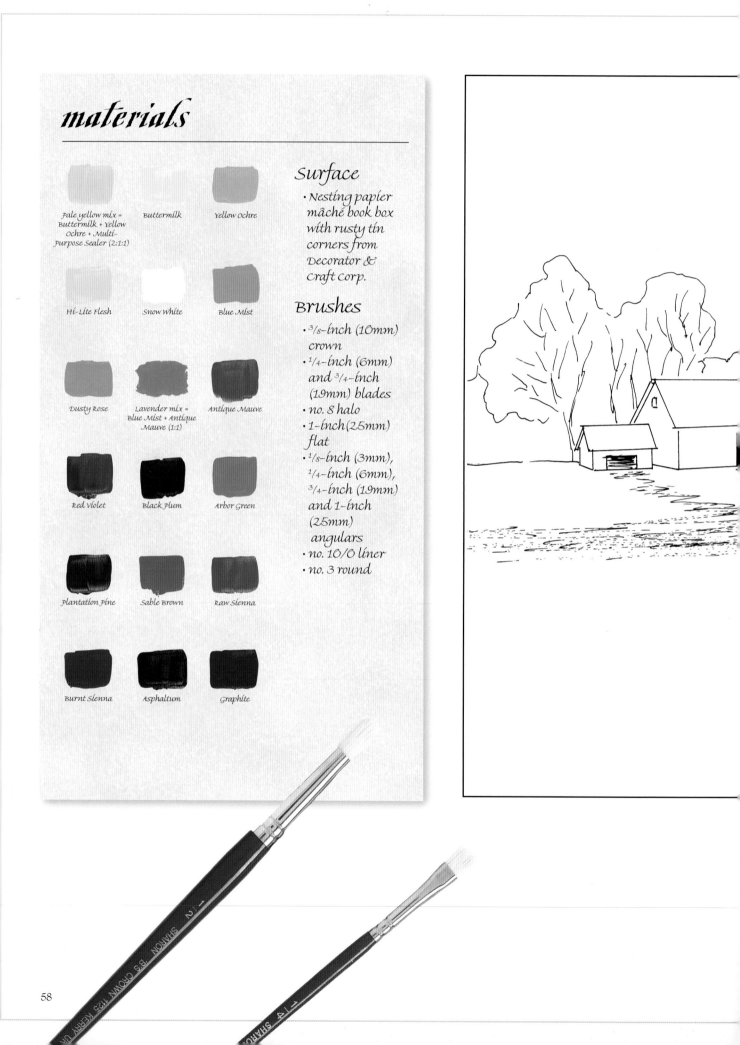

Pale yellow mix =
Buttermilk + Yellow
Ochre + Multi-
Purpose Sealer (2:1:1)

Buttermilk

Yellow Ochre

Hi-Lite Flesh

Snow White

Blue Mist

Dusty Rose

Lavender mix =
Blue Mist + Antique
Mauve (1:1)

Antique Mauve

Red Violet

Black Plum

Arbor Green

Plantation Pine

Sable Brown

Raw Sienna

Burnt Sienna

Asphaltum

Graphite

Surface

- Nesting papier mâché book box with rusty tin corners from Decorator & Craft corp.

Brushes

- ³/₈-inch (10mm) crown
- ¹/₄-inch (6mm) and ³/₄-inch (19mm) blades
- no. 8 halo
- 1-inch (25mm) flat
- ¹/₈-inch (3mm), ¹/₄-inch (6mm), ³/₄-inch (19mm) and 1-inch (25mm) angulars
- no. 10/0 liner
- no. 3 round

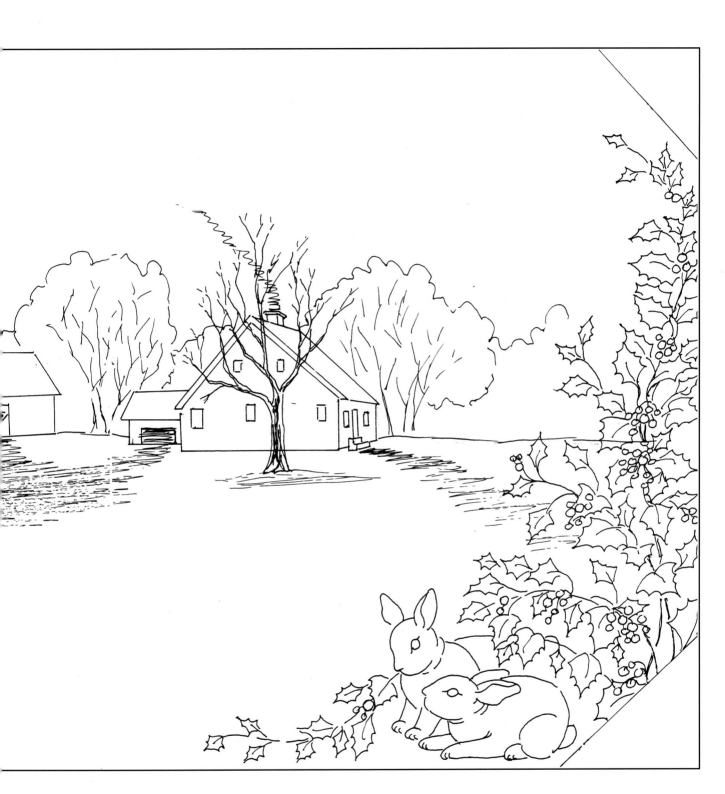

This pattern may be hand-traced or photocopied for personal use only. Reattach the two parts of the pattern, then enlarge at 133 percent to bring to full size.

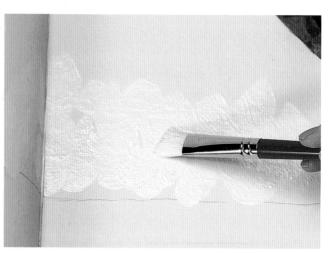

1 Paint two coats of pale yellow mix on all surfaces except the tin corners. You may need to paint a third coat due to the absorbency of the papier-mâché. Transfer only the horizon line using gray graphite paper and a stylus.

Mix Blue Mist + Antique Mauve (1:1) for lavender mix and save on a Sta-Wet palette.

2 Dampen the sky on the front and binding edge. In the center of the sky and next to the horizon line apply thinned pale yellow mix with choppy brushstrokes using the ¾-inch (19mm) blade. Hold the box open to allow the paint to cover the crease on the binding edge.

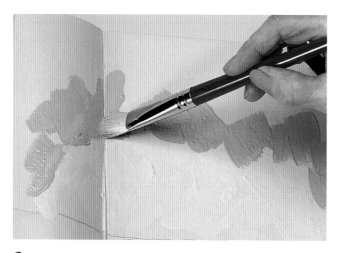

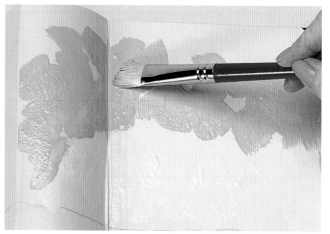

3 Next, add a semicircle of Dusty Rose around the pale yellow area using the ¾-inch (19mm) blade. The brushstrokes should be choppy and should leave a mottled appearance.

4 Add Blue Mist around the Dusty Rose area in the same way.

Hint

The papier-mâché will separate on the binding edge if the book is closed and then opened after the paint has dried.

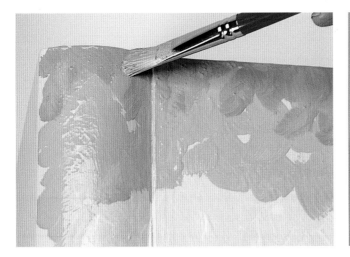 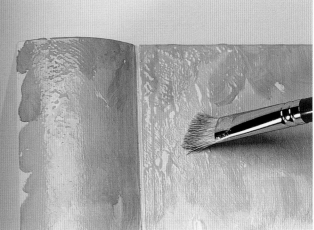

5 Paint the lavender mix around the Blue Mist. Use only the water in your brush to thin each color; the damp surface will provide enough moisture to further thin the paints.

6 Wipe the blade brush each time you blend where the colors meet. Do not overblend.

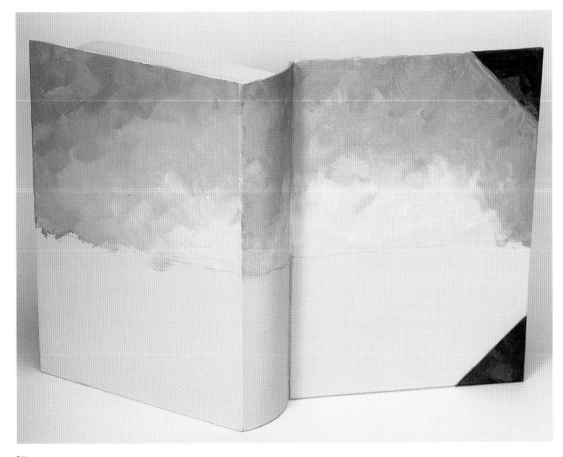

7 Repeat this procedure for the back of the book box. Let dry.

Snow Reflections

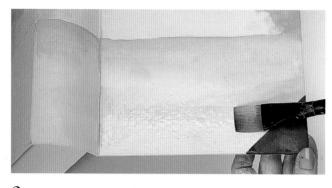

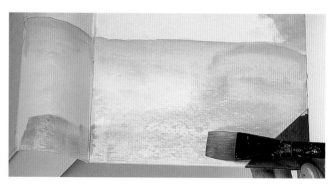

8 Dampen the area below the horizon line. While wet, pull Blue Mist along the horizon line and walk down your 1-inch (25mm) flat to fade the color into the surface. Pull a few horizontal shadows out from the sides using a side load of Blue Mist on the 1-inch (25mm) flat.

9 Add lavender mix to further deepen the shadows. Use the same brush and procedure for each color.

10 Now include horizontal tints of Dusty Rose between the blue and the lavender.

11 Add pale yellow mix tints.

12 Repeat this procedure for the back of the book box.

Clouds and Additional Snow

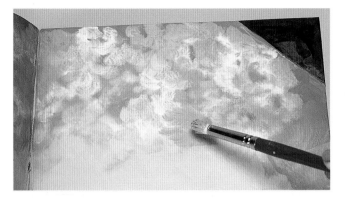

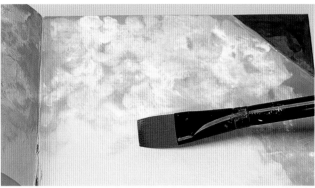

13 Moisten the sky and scumble Hi-Lite Flesh clouds using a fully loaded ⅜-inch (10mm) crown. While wet, add Dusty Rose clouds in the same way, allowing the colors to melt where they overlap.

14 Blend the colors horizontally by lightly dragging with the 1-inch (25mm) flat brush.

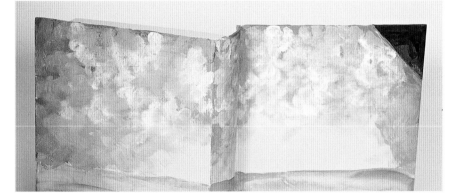

15 Repeat the clouds on the back of the box in the same way.

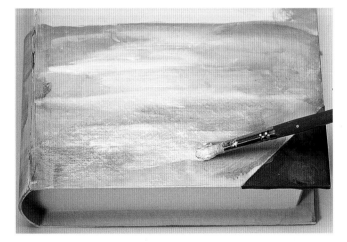

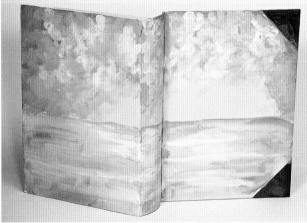

16 Dampen the snow area below the horizon line. Add snow above the shadow areas with Hi-Lite Flesh using the ⅜-inch (10mm) crown. This will be slightly textured and should not be blended.

17 Repeat this procedure for the back of the book box.

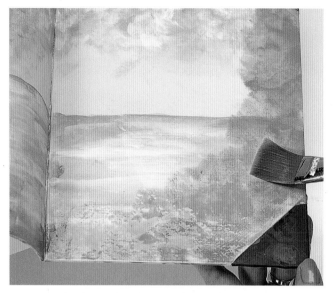

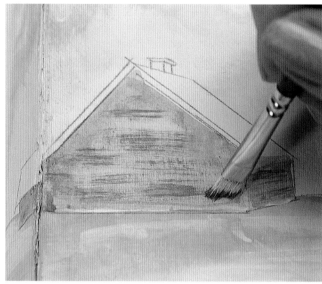

18 Dry the surfaces well, remoisten and add thinned Arbor Green with choppy brushstrokes using the 1-inch (25mm) flat. This color will be under the holly, berries and bunnies design that you will paint later.

19 Transfer the buildings with gray graphite paper, a ruler and a stylus. Basecoat them with pale yellow mix and let dry. Wash the buildings with thin Raw Sienna using the ¼-inch (6mm) angular. Using a scant amount of Raw Sienna on the chisel edge of the ¼-inch (6mm) blade, horizontally drybrush the siding on the house. Repeat this procedure on the barn and other buildings, but pull the strokes vertically.

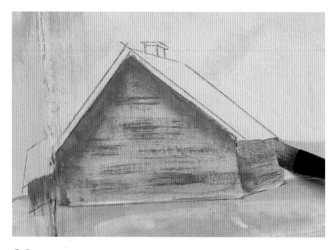

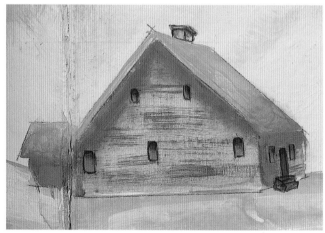

20 Shade all the buildings with a side load of Raw Sienna using the ¼-inch (6mm) angular. Repeat the shading with lavender mix to cool and darken.

21 Basecoat the windows and open door with lavender mix. Base the front door of the house with Raw Sienna. Shade the top of the windows and the doors with a side load of Graphite on the ⅛-inch (3mm) angular. Detail the buildings with Graphite linework using the no. 10/0 liner. Paint the roofs with Blue Mist, and shade the bottoms with a side load of lavender mix on the ¼-inch (6mm) angular.

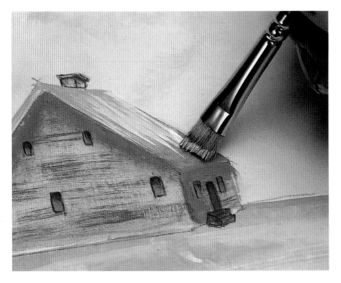

22 Drybrush snow onto the roofs with Hi-Lite Flesh using the chisel edge of the ¼-inch (6mm) blade. Be sure that you follow the angle of the roofs.

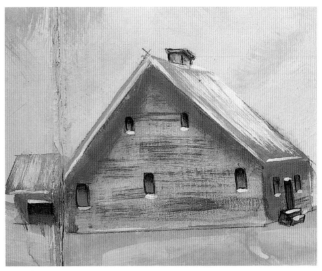

23 Add Hi-Lite Flesh linework on the roof edges, the tops of the doors and the bottoms of the windows using the no. 10/0 liner. Paint the front steps using lavender mix with Graphite detailing, and paint snow using Hi-Lite Flesh and the no. 1 liner.

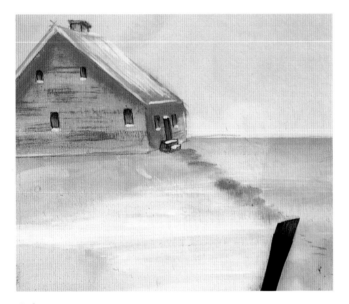

24 Dampen the pathway areas. Paint them using Raw Sienna on the ¼-inch (6mm) angular with a zigzag stroke. Start next to the buildings and make it fade off.

Background and Foreground Trees

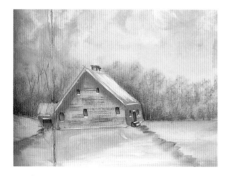

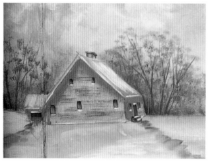

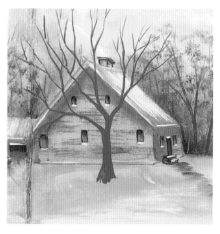

25 Dampen around the buildings. While it is still wet, paint the background trees by tapping on lavender mix using the ⅜-inch (10mm) crown. Start at the horizon line and tap up to fade off the top. Dry, remoisten and add a side load of Graphite next to the buildings using the ¾-inch (19mm) angular. Dry, then add lavender mix linework trunks and branches using the no. 10/0 liner.

26 Paint Raw Sienna linework using the no. 10/0 liner. Apply clean water on the trees and, while still wet, dab on delicate leaf clumps with Raw Sienna using the tip of the ¼-inch (6mm) blade.

27 Side load Hi-Lite Flesh on your ¼-inch (6mm) angular and create the smoke from the chimney with a zigzag stroke. Trace on the brown tree in front of the house using gray graphite paper and a stylus. Paint it Sable Brown using the no. 10/0 liner.

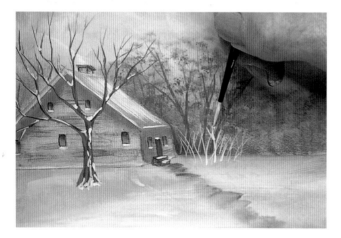

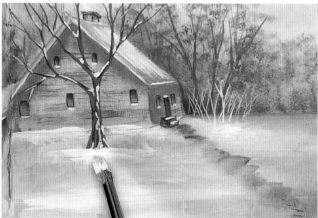

28 Paint the detail linework with Graphite, and paint the snow on the tops of the branches and along the trunk with Hi-Lite Flesh using the no. 10/0 liner. Paint the snowy bushes using Hi-Lite Flesh and the no. 10/0 liner.

29 Anchor the buildings, bushes and trees in the snow by horizontally pulling Hi-Lite Flesh. Use the ⅜-inch (10mm) crown. Snow White may be added to brighten the center areas of the snow.

Holly Leaf and Berries Border

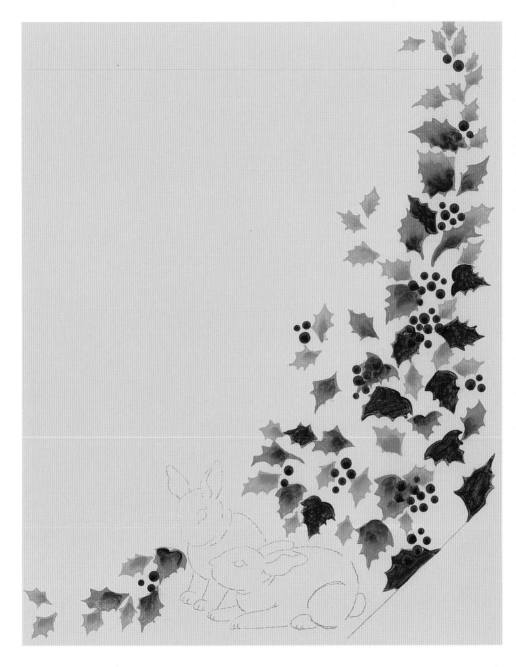

30 To make it easier to see how to paint the holly and bunnies, I've painted them here without the background. Transfer on the design using gray graphite paper and a stylus. Basecoat the light leaves with Blue Mist, the medium leaves with Arbor Green and the dark leaves with Plantation Pine. Basecoat the berries with Antique Mauve using the no. 3 round.

Shade the blue leaves with a side load of Arbor Green, and shade the green leaves with Plantation Pine using the ¼-inch (6mm) angular. There is no additional shading on the dark leaves. Using the ⅛-inch (3mm) angular side loaded with Red Violet, shade the bottom of the berries.

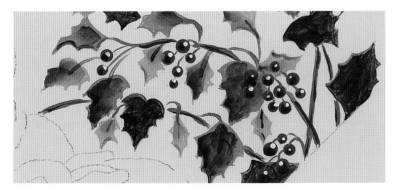

31 Tint a few of the light and medium leaves with a side load of Red Violet on the ¼-inch (6mm) angular. Be careful not to overtint and change the color. Place a highlight dot of Hi-Lite Flesh on the top of each berry. Create the branches and twigs with Sable Brown linework and Graphite detailing using the no. 10/0 liner. Detail the edges of the leaves with Plantation Pine to make them look pointy, and add a center vein using the no. 10/0 liner.

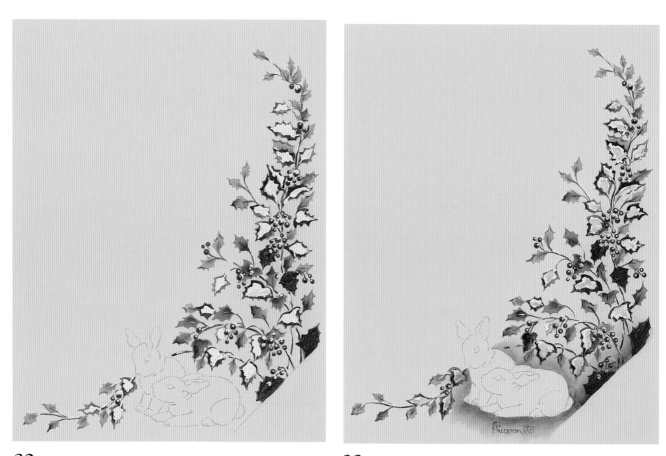

32 Using the tip of the ¼-inch (6mm) blade, scoop up Hi-Lite Flesh and dab heavy snow onto a few holly leaves. Using the no. 1 liner, apply heavy snow to a few berries and branches, and let dry.

33 Shade the snow applications with thinned Blue Mist using the no. 3 round brush and the no. 1 liner for the smaller areas.

Apply shading under the holly tree with a side load of Plantation Pine on the 1-inch (25mm) angular. Repeat this step several times for cool, dark shadows.

Bunnies

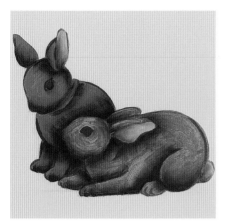

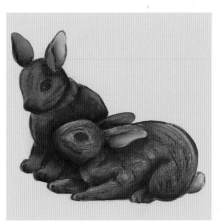

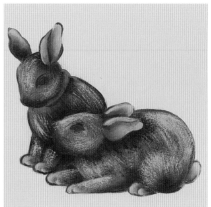

34 Transfer using gray graphite paper and a stylus. Basecoat the bunny in back with Sable Brown and the front bunny with Raw Sienna using the round brushes. Paint the eyes with Graphite and the tail and inside of the ears with Dusty Rose. Fill in the negative space between the legs and detail around the bunnies with Graphite on the no. 10/0 liner.

With Burnt Sienna side loaded on the ¾-inch (19mm) angular, shade the front bunny's head and ears and separate body parts. Side load Asphaltum on the ¼-inch (6mm) angular, and shade the same areas on both bunnies to build form.

35 For the third shading, use Black Plum on the ⅛-inch (3mm) angular and shade in only the darkest areas. Shade the inside of the ears and the tail first with Sable Brown and then with Asphaltum using a side-loaded ¼-inch (6mm) angular.

Start forming fur using the chisel edge of the ¼-inch (6mm) blade and a scant amount of Asphaltum. Pull in the direction of growth.

36 Add a scant amount of Black Plum fur in the darkest areas where shading was previously placed. Use the tip of the ¼-inch (6mm) blade.

Highlight with Yellow Ochre fur on the front of the faces, cheeks, top of the back, legs and chests in the same way. Side-load float Yellow Ochre on the tips of the ears, paws and top of the tail using the ¼-inch (6mm) angular.

37 Using Hi-Lite Flesh, paint a fine line to the top and bottom of the eyes with the no. 10/0 liner. Add a life spark in the eyes, fine linework whiskers and a blaze in the center of the eyes in the same way. Detail any additional body fur using Yellow Ochre linework.

Dab the ground under the bunnies first with Yellow Ochre on the tip of the ¼-inch (6mm) blade. Apply Raw Sienna then Burnt Sienna in the same way. Let dry, then side-load float Asphaltum shading next to the base of the bodies with the ¾-inch (19mm) angular.

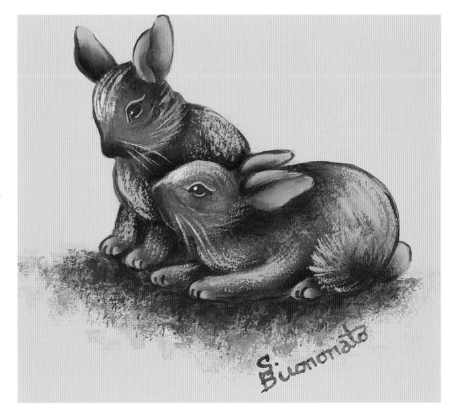

Book Pages

38 Drybrush Raw Sienna using a half-loaded no. 8 halo, and drag each side straight down.

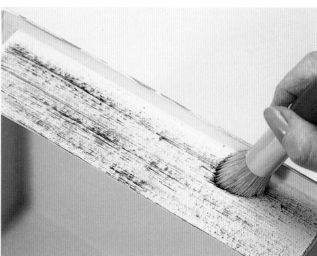

39 Repeat this procedure using Asphaltum.

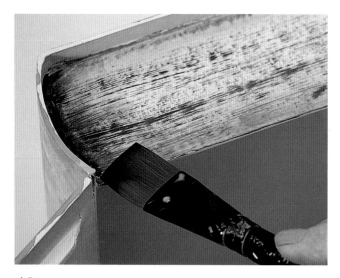

40 Side-load float Raw Sienna along the edges next to the book covers and the binding using the 1-inch (25mm) flat. Add Asphaltum to darken the curved binding. Shade in the same way.

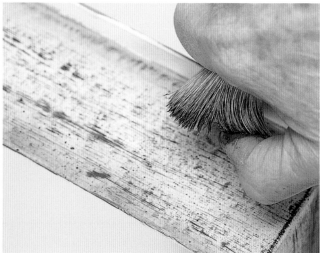

41 Spatter the book pages with thin Asphaltum using the no. 8 halo.

Antiquing

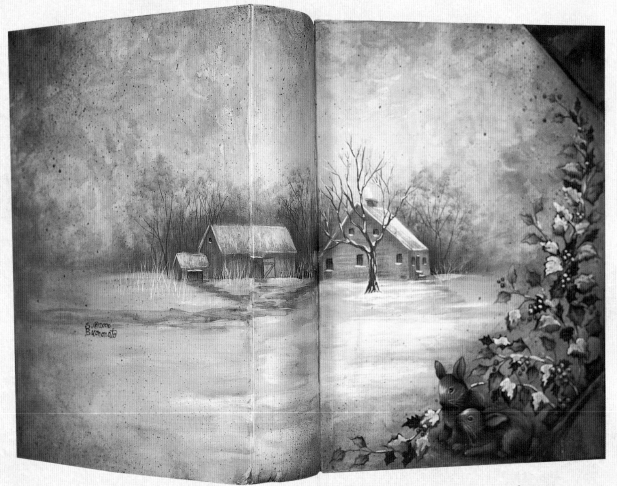

42 Dampen the surfaces and apply a very thin glaze of Asphaltum next to the rusty tin corners and along the outside edges of the book box. Use the 1-inch (25mm) flat. Wipe the brush and walk the glaze toward the center of the box, leaving the darkest color on the edges. The center should not have any glaze on it. Dry, remoisten and apply a side load of Asphaltum using the 1-inch (25mm) angular only in the darkest areas. When dry, spatter with thin Asphaltum using the no. 8 halo brush. Quickly wipe any spatters off the bunnies with a dampened cotton swab. Let dry, and apply several coats of DecoArt DuraClear Varnish. Note: The antiquing will soften and darken the bunnies, holly, leaves and snow in these areas. This is desired to achieve the aged look on the surface and produce a warm glow in the center design areas.

Hint

If you wish to antique the inside of the boxes, first apply a wash of Blue Mist, leaving choppy brushstrokes using the 1-inch (25mm) angular. Dry and redampen, then apply a wash of Raw Sienna in the corners of the box with the 1-inch (25mm) angular. Walk the color out toward the center areas. Leave the choppy brushstrokes showing to create a mottled appearance. Dry and repeat with a glaze of Asphaltum. To finish, spatter using the no. 8 halo and thin Asphaltum. Let dry and apply several coats of DecoArt DuraClear Varnish.

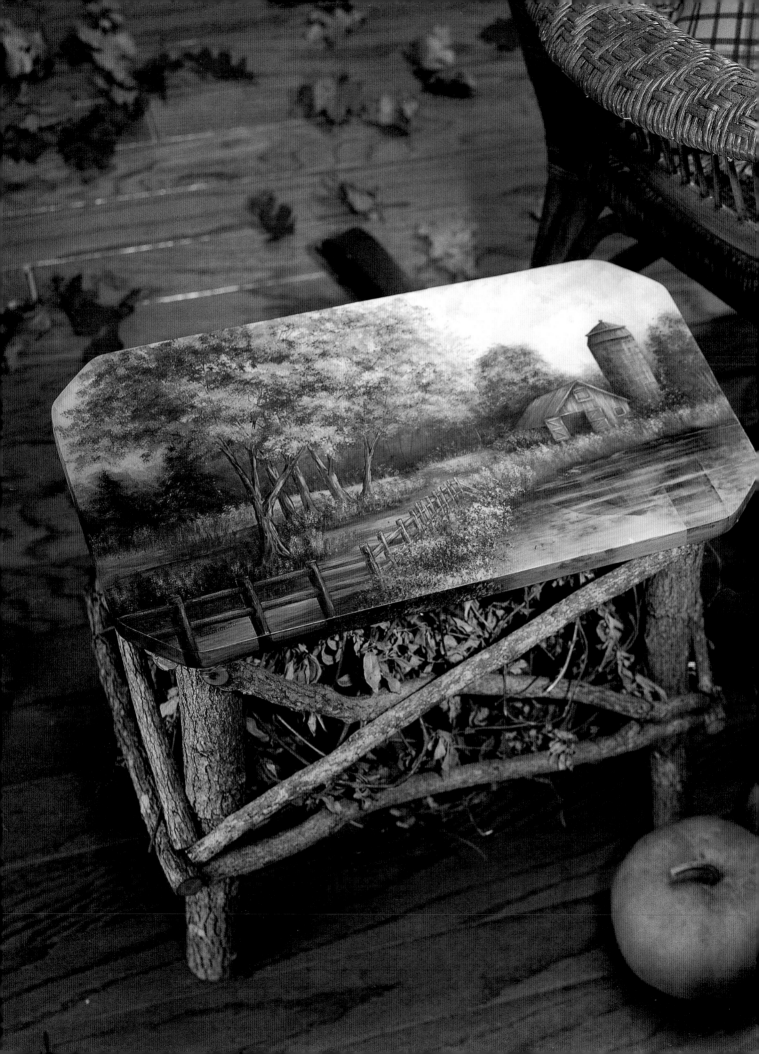

Project Four

Rustic Autumn Barn

It is no secret that autumn is my favorite season of the year! This project provides you with many elements that are key lessons in acrylic landscape painting. Water reflections play an important role in this design as well as color control of the vibrant autumn trees. Before painting the entire scene, try some of these new elements, such as the barn, silo and reflecting pond, on a smaller surface. This will help you to become more familiar with the painting process.

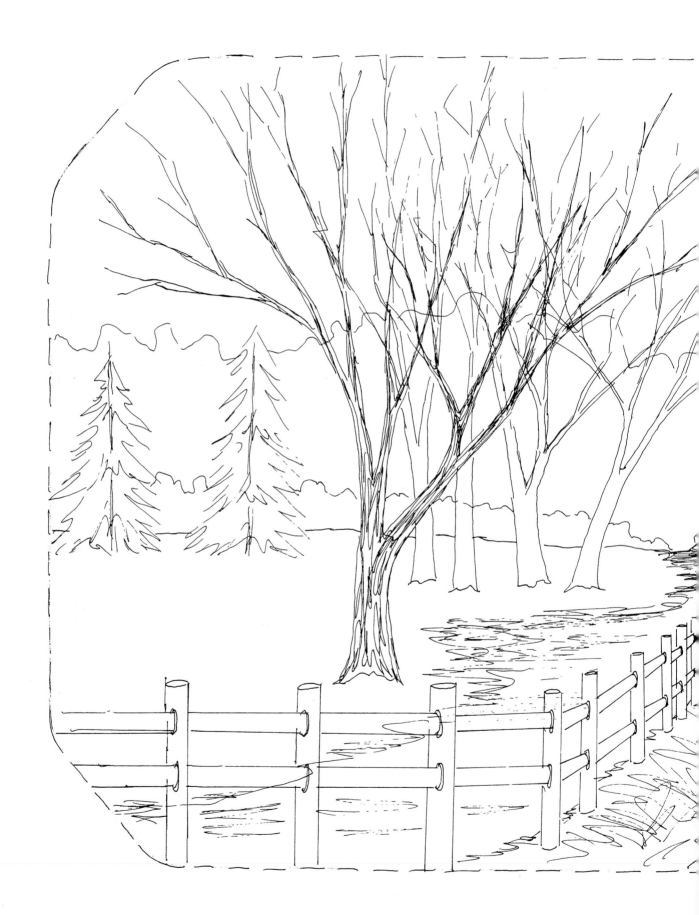

This pattern may be hand-traced or photocopied for personal use only. Reattach the two parts of the pattern, then enlarge at 133 percent to bring to full size.

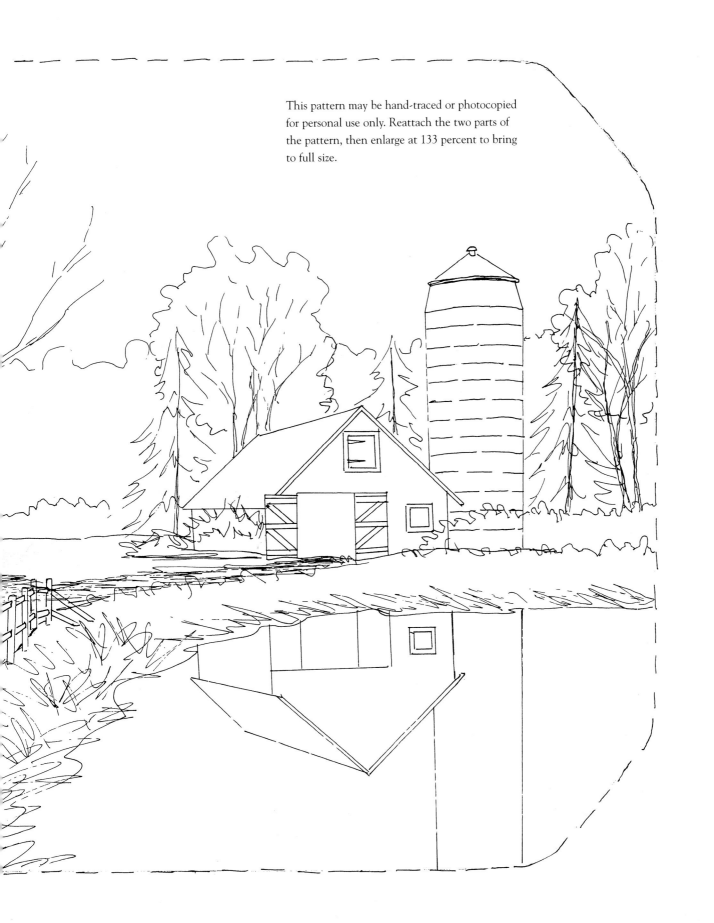

materials

Pale yellow mix =
Buttermilk + Yellow
Ochre + Multi-
Purpose Sealer (2:1:1)

Buttermilk

Yellow Ochre

Hi-Lite Flesh

Blue Mist

Pansy
Lavender

Plum

Black Plum

Moon Yellow

Cadmium
Yellow

Pumpkin

Cadmium
Orange

Coral Mix =
Cadmium Red +
Moon Yellow (2:1)

Cadmium Red

Cherry Red

Sable Brown

Burnt Sienna

Asphaltum

Jade Green

Antique Green

Plantation Pine

Evergreen

Sapphire

Midnite Blue

Neutral Grey

Graphite

Surface
- Bench with cut-corner pine top and twig and vine base from Crews Country Pleasures

Brushes
- 3/8-inch (10mm) and 3/4-inch (19mm) blade
- 3/4-inch (19mm) crown
- 1/4-inch (6mm) and 1-inch (25mm) angulars
- no. 8 halo
- nos. 10/0 and 1 liners
- nos. 3 and 6 rounds
- 1-inch (25mm) flat
- no. 1 mop

Basic Elements

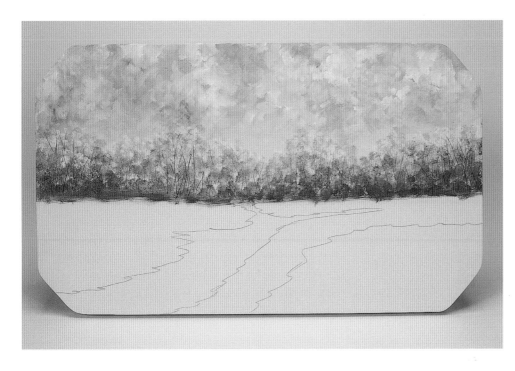

1 Basecoat the top surface and edges with pale yellow mix. Lightly sand and wipe the surface, then transfer the horizon line, roads and pond using gray graphite paper and a stylus.

The sky, clouds, background trees, foreground trees, grass areas, road, fence, foreground bushes, pond and silo reflections continue onto the outside edge of the bench top. For instructions for sky and clouds, refer to pages 25-26. For instructions for the background trees, refer to page 27, steps 12 and 13.

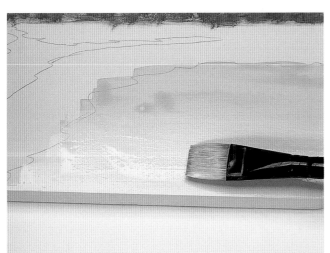

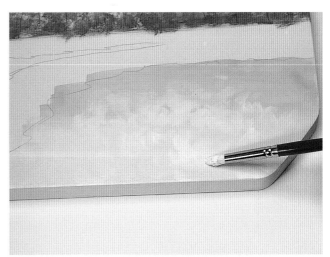

2 Dampen the pond, and apply thinned Blue Mist to the top and walk down. Use the 1-inch (25mm) flat. Apply thinned pale yellow mix to the bottom of the pond and walk it up into the blue. Wipe the brush and blend horizontally where the two colors meet.

3 While the surface is still wet, add cloud reflections with the ⅜-inch (10mm) crown loaded with Hi-Lite Flesh. Let dry.

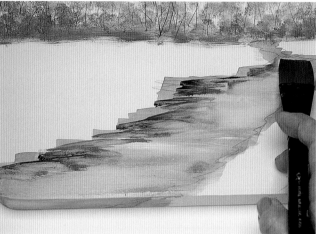

4 Apply a thin wash of Burnt Sienna using the 1-inch (25mm) flat. Highlight with a side load of Moon Yellow on the 1-inch (25mm) flat using horizontal streaks.

5 Add Asphaltum shading in the same way along the left edge of the road in a zigzag motion. Let dry.

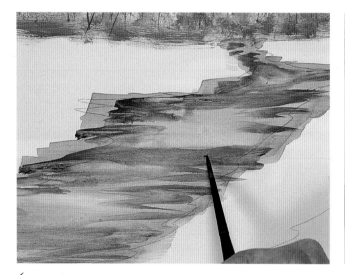

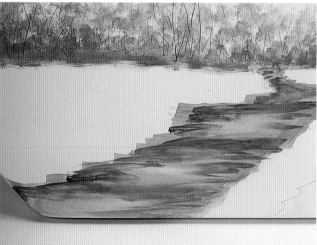

6 Remoisten the surface and paint Asphaltum zigzag strokes along the right side of the road. Create the ruts with horizontal strokes of Asphaltum using the no. 3 round.

7 Add tints of Pumpkin horizontally between the ruts in the same way. Let dry.

Grass

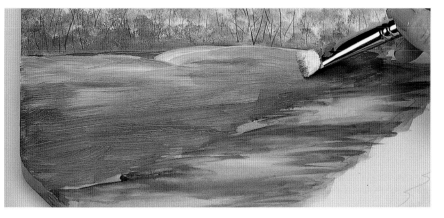

8 Using the ¾-inch (19mm) blade, apply Antique Green starting at the horizon line. Move down in horizontal strokes. While the paint is still wet, add Moon Yellow highlights to the center top and walk down horizontally.

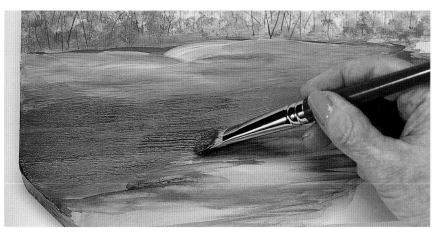

9 Apply Plantation Pine shading in the same way, starting at the left edge and streaking over toward the road.

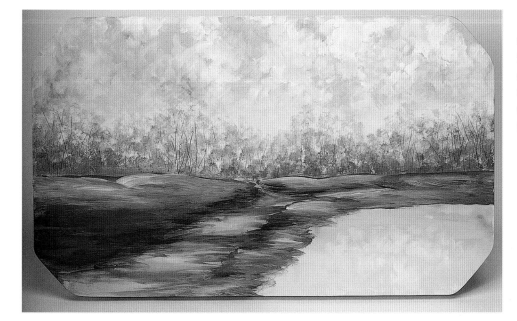

10 Tint horizontally with a small amount of Asphaltum "dirt" between the road and the grass. Use the same method to paint the grass areas on the right side of the road.

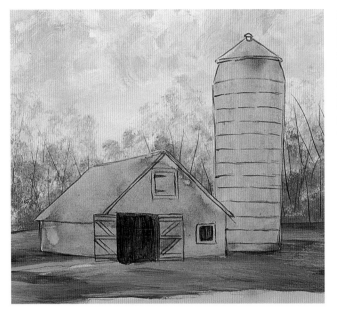

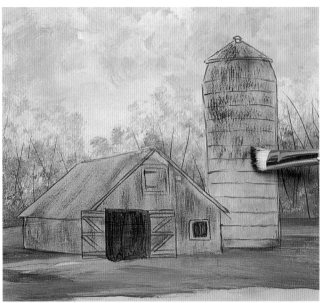

11 Trace on the pattern using gray graphite paper, a ruler and a stylus. Basecoat the buildings with pale yellow mix using the 1-inch (25mm) angular and the no. 3 round. Using the 1-inch (25mm) flat, apply a thin wash of Burnt Sienna on the buildings and allow to dry. Vertically streak inside the door and the windows with Asphaltum using the no. 3 round brush. Outline and detail everything with Graphite using the no. 10/0 liner.

12 Following the shape of the roofs, drybrush wood grain using a scant amount of Burnt Sienna on the chisel edge of the ⅜-inch (10mm) blade. Do the same for the siding, except use vertical strokes on the barn. Notice that the silo has many sections with the same vertical dry brushing.

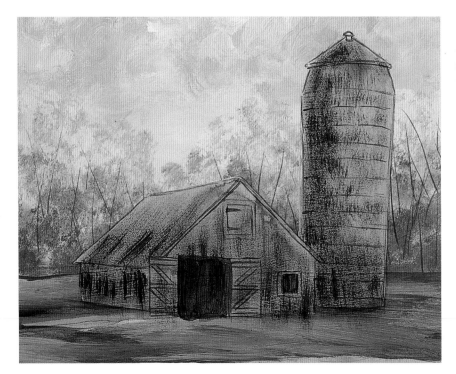

13 Repeat this procedure with Asphaltum shading only in the darkest areas: the extreme left of the barn and the silo, the left sides of the roofs and at the bases of both buildings.

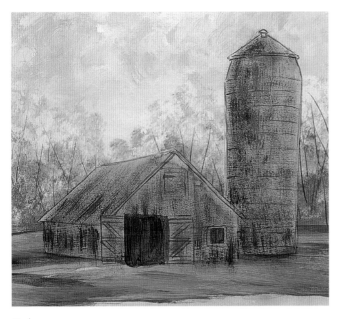

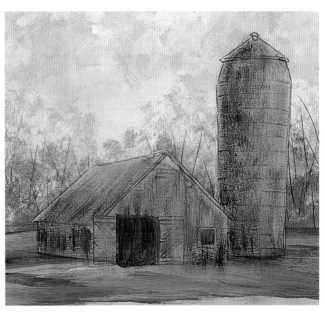

14 Weather the siding by adding tints of Neutral Grey with the ⅜-inch (10mm) blade. Drybrush the color using the chisel edge of the brush.

15 Using the same procedure as in step 14, add sunshine with Cadmium Yellow tints to the right side of the silo, the front of the barn and doors and the top of the roof. Sprinkle in Pumpkin tints in the same way.

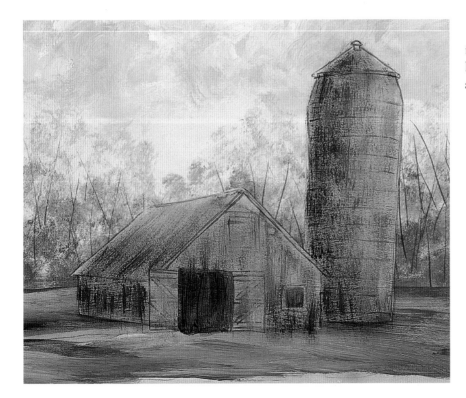

16 In the same way, drybrush Plum in the dark areas and in the extreme left and the bottom right of the barn and silo.

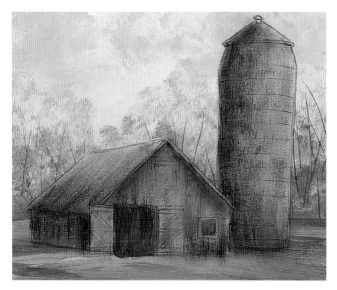

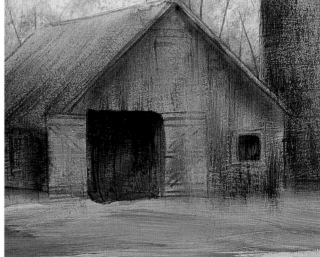

17 Dampen the surface and side-load float Black Plum over the shaded areas under the eaves using the 1-inch (25mm) angular. Anchor the buildings with a float of Graphite at the base in the same way.

18 Shade the tops of the window and the door using a side load of Black Plum on the ¼-inch (6mm) angular.

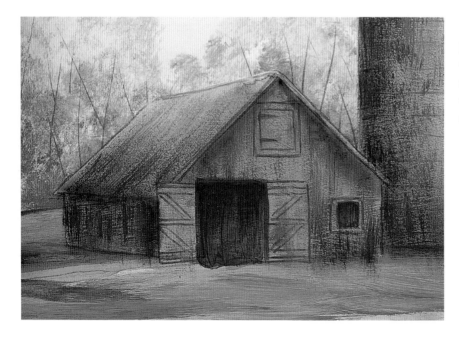

19 Darken these areas with another layer of Graphite shading in the same way. Detail with Graphite linework using the no. 10/0 liner on the framework, the door hinges, the horizontal sections of the silo and the roof lines.

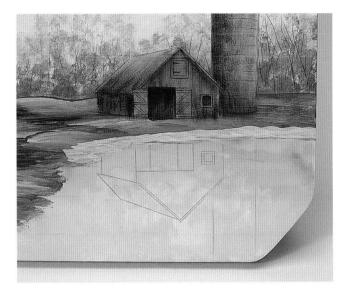

20 Trace on the shoreline and the reflections with gray graphite paper and a stylus. Continue the silo reflection lines over the edge of the bench top using a ruler and a pencil. With pale yellow mix on the no. 6 round, paint the shoreline wrapping around the right outside edge of the bench. If the sky reflections are dark, you may need to basecoat the reflected buildings with pale yellow mix.

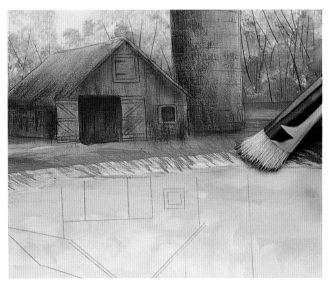

21 Using the chisel edge of the ¾-inch (19mm) blade and Antique Green, apply diagonal streaks from the top of the shoreline to the edge of the pond.

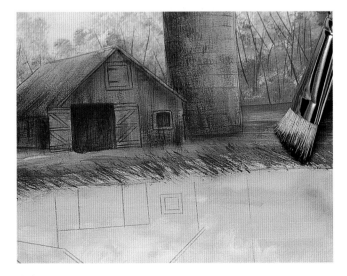

22 Add Evergreen streaks and Asphaltum "dirt" to the shoreline in the same way.

23 Apply a thin wash of Burnt Sienna to the reflected buildings with the 1-inch (25mm) flat. Vertically drybrush on the wood grain using the chisel edge of the ⅜-inch (10mm) blade. You do not need to separate the sections of the silo.

24 Apply Asphaltum in the shading areas in the same way using the ⅜-inch (10mm) blade.

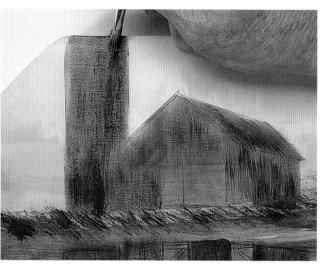

25 Add tints of Neutral Grey in the same way.

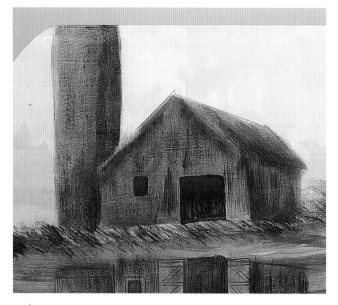

26 Base the window and door with Asphaltum and the no. 3 round. Shade with a Black Plum float at the tops. Darken these areas with Graphite using the ¼-inch (6mm) angular. Shade under the eaves, the bottom of the roof and the right side of the silo with a float of Burnt Sienna using the 1-inch (25mm) angular.

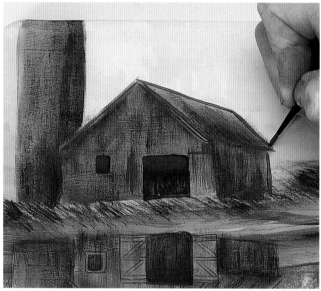

27 Paint a thick outline on the reflected buildings using Graphite and the no. 10/0 liner.

Pine Trees

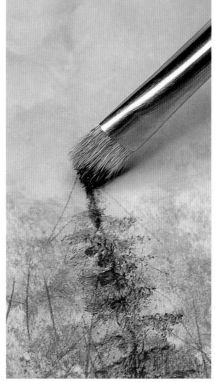

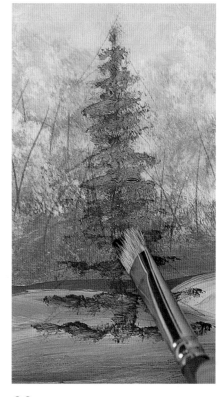

28 There are five pine trees located on your pattern. Start with the two large pines to the left of the road. Using the tip of the ¾-inch (19mm) blade loaded with Plantation Pine, start forming the pine tree at the center base with a tapping motion. Tap from the center out to the right, back to the center, then out to the left. Continue loading and tapping on the boughs in the same way, forming a conical skeleton.

29 When you reach the top, turn the blade sideways and tap on a point.

30 Tap back down the tree to fill in the boughs in the same way.

31 For more body and depth, darken the centers and base with Evergreen in the same way. Cool the left side of the boughs with Blue Mist tints.

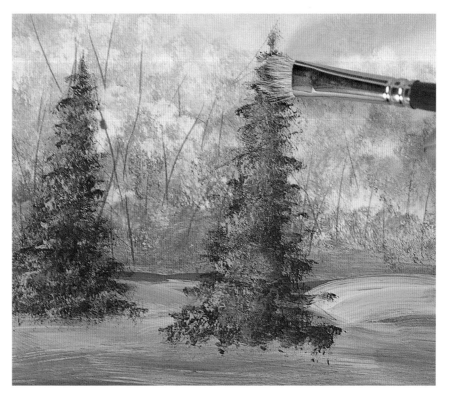

Vine and Background Trees

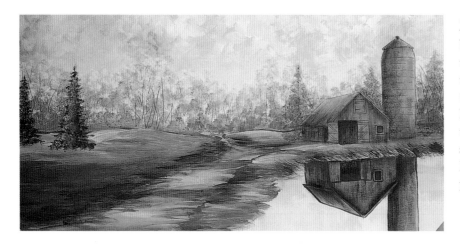

32 To make the three pine trees behind the buildings appear more distant, dampen the surface and paint the trees using a tip-loaded ⅜-inch (10mm) blade with Plantation Pine. Paint a vine climbing on the silo using the tip of the ⅜-inch (10mm) blade and Antique Green. Add in some Plantation Pine shading, using less paint for this delicate application.

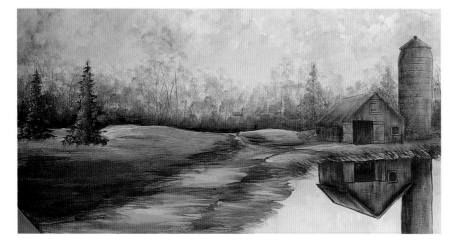

33 Dampen the horizon line, then side-load float Black Plum on the 1-inch (25mm) flat. Place this color on top of the background trees to darken them.

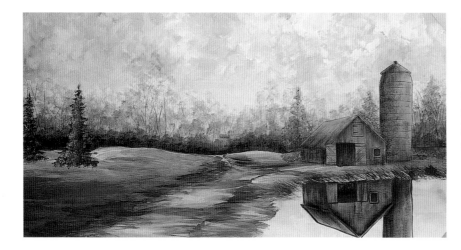

34 To form the orange bushes, tap along the horizon with a tip load of Cherry Red on the ⅜-inch (10mm) blade. Add Black Plum to the base of the bushes in the same way. With coral mix (Cadmium Red + Moon Yellow) highlight the tops of the bushes with the tip of the ⅜-inch (10mm) blade.

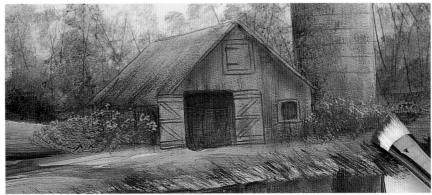

35 Load the chisel edge of the ⅜-inch (10mm) blade with Cadmium Red. Tip the lower end in Cherry Red and the high end in coral mix.

36 Tap the brush on the palette, blending the colors. Then, form fan-shaped bushes along the left side of the barn and under the silo on the right.

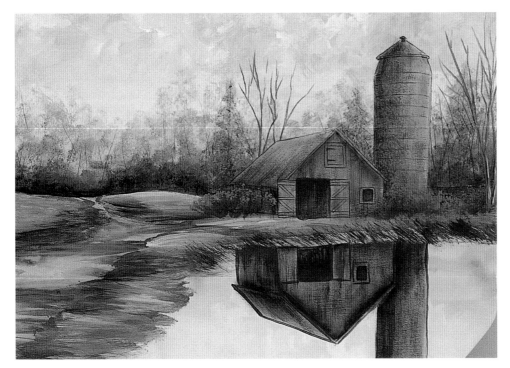

37 Paint the red trees' trunks and branches with Sable Brown and the no. 10/0 liner. Add Asphaltum detailing and Moon Yellow for sunshine on the main trunks and branches.

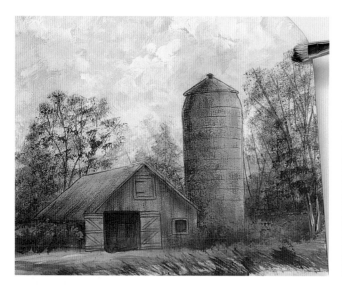

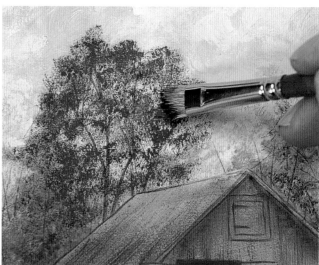

38 Using the tip of the ⅜-inch (10mm) blade, paint the leaves with Cherry Red to form delicate leaf clumps.

39 Sprinkle in Cadmium Red and Cadmium Orange on the clumps.

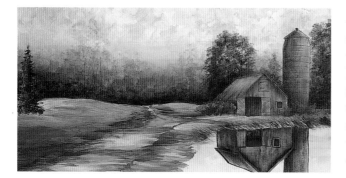

40 Shade the trees with a tad of Black Plum on the base, and highlight Pumpkin to the tops in the same way. Dampen the surface along the horizon line and side-load float Black Plum using a 1-inch (25mm) flat. Walk the paint up away from the horizon line and fade it out into the background trees. Wipe the Black Plum off the orange bushes using a dampened no. 6 round brush. Use this shading to anchor your barn at the base of the small pines and red trees. Let dry and repeat if necessary to darken.

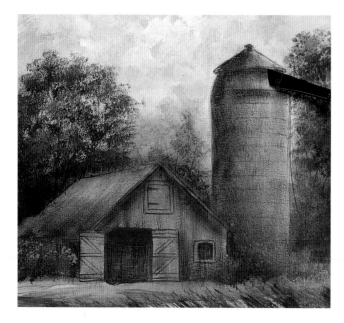

41 Dampen the surface. Float Black Plum on the bottom edge of the barn roof, underneath the eaves on the front and on the outside of the right barn door. Use the ¼-inch (6mm) angular. Also, shade the left side of the silo, under the silo cap and roof in the same way.

Large Trees

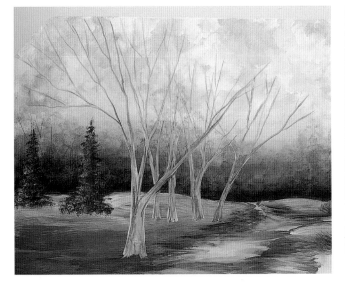

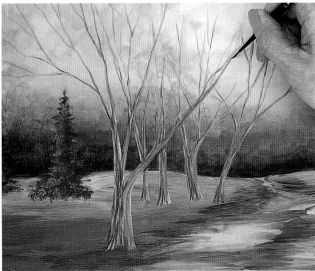

42 Trace the five foreground trees on the left using gray graphite paper and a stylus above the horizon line and white graphite below the horizon line. Use the no. 3 round to paint the trunks with Yellow Ochre, the no. 1 liner for the thicker branches and the no. 10/0 liner for the twigs. Wash over these areas with thinned Burnt Sienna to tint.

43 Detail with Sable Brown to form bark using the same progression of brushes. Next, add Asphaltum mainly to the left and darker sides.

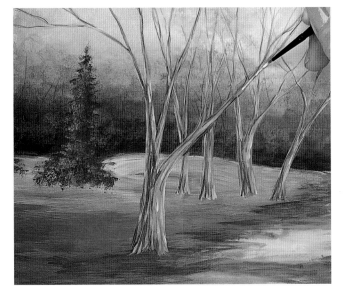

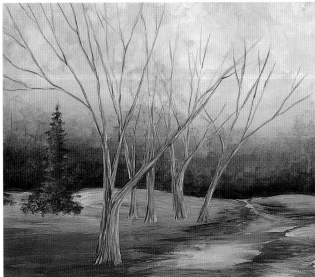

44 Add Pumpkin tints and Cadmium Yellow highlights in the same way.

45 Cool the dark side with Neutral Grey using the liner brushes.

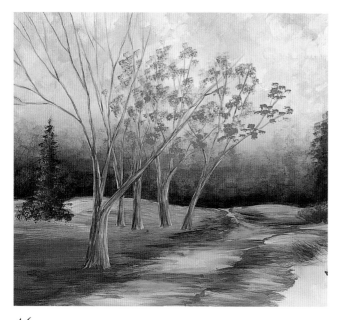

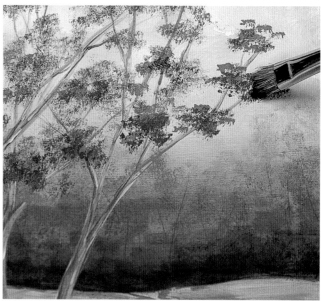

46 Side-load float Plum over the left side of the trunks to cool using the ¼-inch (6mm) angular. With the tip of the ⅜-inch (10mm) blade and Sable Brown, start forming the leaf clumps of the two brown trees to the right of the group of five trees.

47 Add Burnt Sienna to these clumps and Asphaltum to the base to shade in the same way.

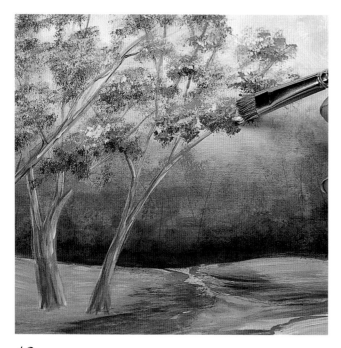

48 Highlight the tops with Pumpkin. Add a tad of Moon Yellow sunshine to only the highest clumps touching the sky. Be sure to leave plenty of sky holes between the leaf clumps.

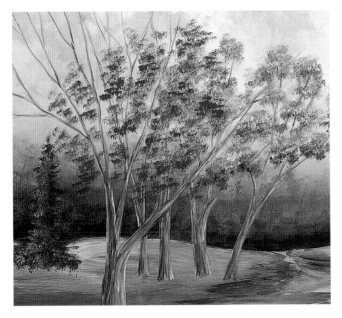

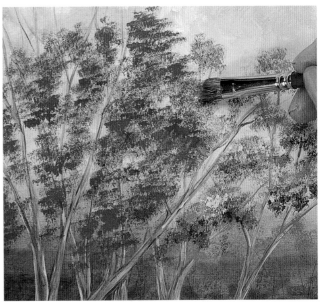

49 For the two red trees, start forming the leaf clumps in the same way as the brown trees, first using Cherry Red on the tip of the ⅜-inch (10mm) blade.

50 Next, add Cadmium Red and Cadmium Orange to the clumps in the same way.

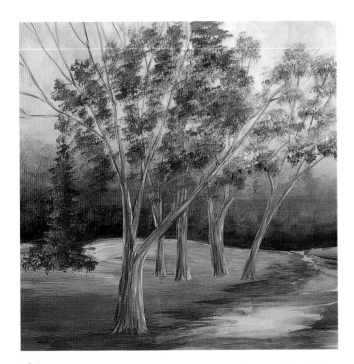

51 Shade the base with a tad of Black Plum and highlight the tops with coral mix.

52 The yellow tree is the largest in front of the other four trees. Concentrate on making the leaf clumps larger since this tree is closer than the others in the group. Form the clumps using Cadmium Orange on the tip of the ¾-inch (19mm) blade.

53 Next, add Pumpkin and Cadmium Yellow in the same way.

54 Shade with a tad of Cadmium Red and Cherry Red to the base. Stay mainly to the left, or darker, side of the tree.

55 Develop new leaf clumps in the same color progression to fill in the tree. Add Moon Yellow to the tops for highlights. Strive to maintain some sky holes and areas where the brown and red trees peek through the yellow leaf clumps. All five foreground tree branches and leaves should spill over the outside edges the same as the sky, clouds, bushes, pond, road and fence.

Grasses

56 Load the no. 8 halo with Antique Green three-fourths of the way around the chisel edge. Tap on the palette to blend and open the hair.

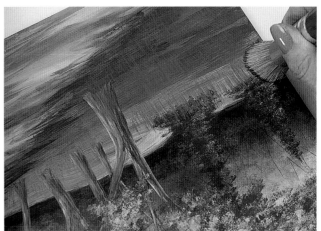

57 Turn the surface upside down and pull up grasses using your loaded halo brush.

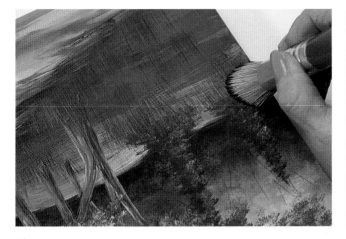

58 Darken the grasses with Evergreen in the same way.

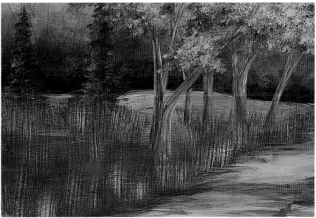

59 Highlight the grasses with Jade Green.

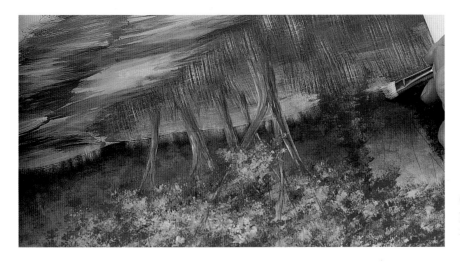

60 Paint shorter grasses along the horizon line using the chisel edge of the ⅜-inch (10mm) blade and Jade Green.

Wildflowers

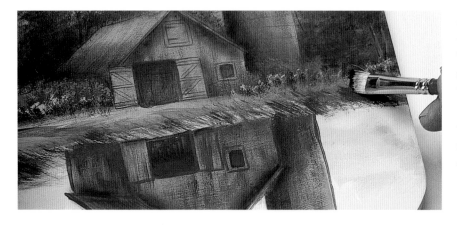

61 Start by loading Evergreen on the chisel edge of the ⅜-inch (10mm) blade. Tip the high end into Jade Green and tap on the palette to blend. With the Jade Green facing up, tap on in front of the barn and the silo. Wipe the brush and load Black Plum on the chisel edge. Dab on to darken the base of the wildflowers.

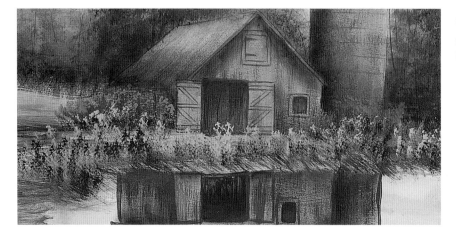

62 Repeat this process along the shoreline making the wildflowers a bit taller by using the ¾-inch (19mm) blade.

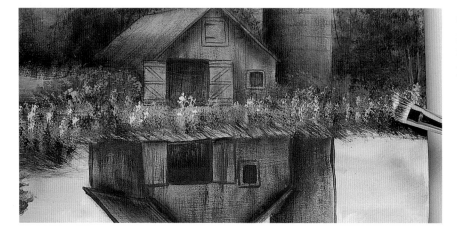

63 Tap on some blue flowers with Sapphire using the chisel edge of the ⅜-inch (10mm) blade. Sprinkle in Moon Yellow flowers in the same way.

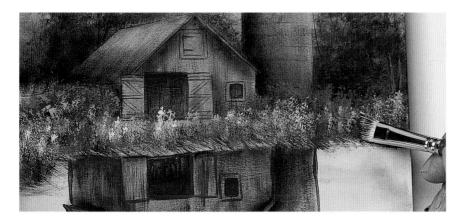

64 Add Cadmium Yellow and Plum flowers in the same way. Make sure the previous colors show.

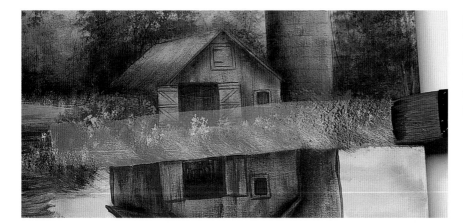

65 Redefine the shoreline with Yellow Ochre using the ⅜-inch (10mm) blade. Diagonally drybrush up toward the wildflowers, then warm with a thin wash of Burnt Sienna on the 1-inch (25mm) flat.

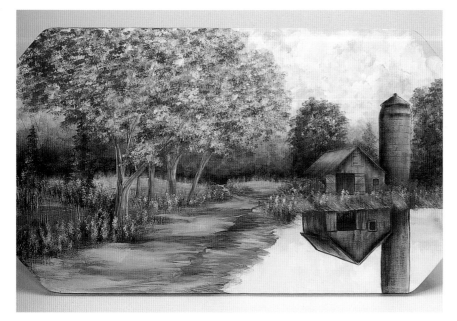

66 Finish the wildflowers on the left side under the trees. Redefine the road edge with Yellow Ochre dry-brushed horizontally into the base of the wildflowers and grasses. Wash over with a thin wash of Burnt Sienna and the 1-inch (25mm) flat.

Fence

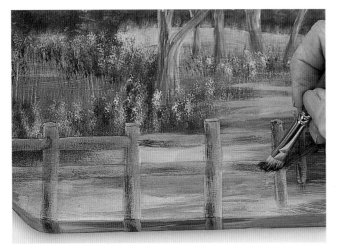

67 Trace on the fence posts and rails using a ruler, gray graphite paper and a stylus. Basecoat the fence with Yellow Ochre using the round brushes. Wash over with a thin application of Burnt Sienna to tint. Detail with Sable Brown and Asphaltum wood graining by drybrushing. Use the tip and chisel edge of the ⅜-inch (10mm) blade.

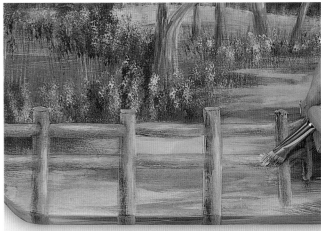

68 Add Pumpkin tints and Cadmium Yellow highlights in the same way with the same brush.

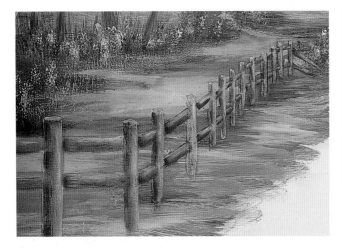

69 Use Neutral Grey to weather and age the fence in the same way. Let dry. Side-load float Black Plum to the left sides of the posts and the bottoms of the rails using the ¼-inch (6mm) angular.

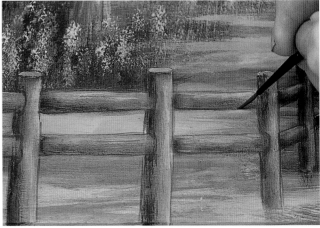

70 Detail the fence with Graphite and the no. 10/0 liner.

Reflections

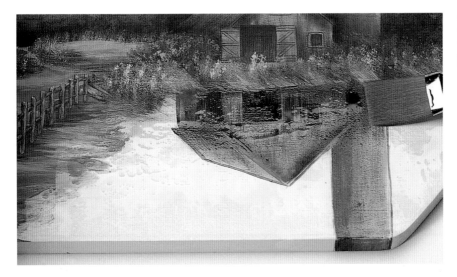

71 Dampen the pond with clean water and the 1-inch (25mm) flat brush.

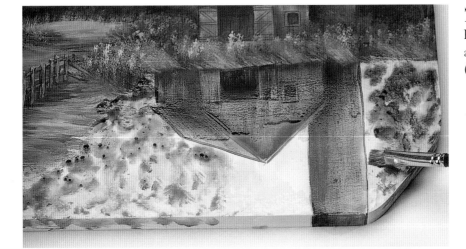

72 While still wet, dab on Cherry Red, Cadmium Red, Cadmium Orange and Plum using the tip of the ⅜-inch (10mm) blade.

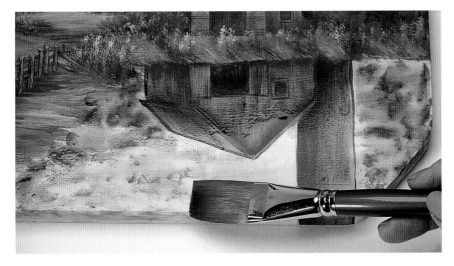

73 Lightly drag the 1-inch (25mm) flat brush horizontally through the colors to bleed and soften them into the pond. Let dry.

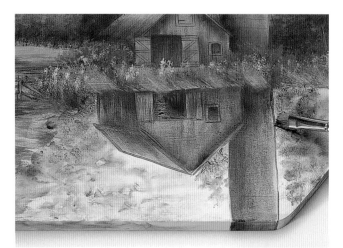

74 Redampen and add the green tree colors in the same way: first Plantation Pine, then Evergreen in the areas where the green trees are growing.

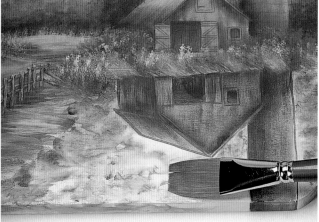

75 Streak through these colors horizontally with the 1-inch (25mm) flat. Let dry.

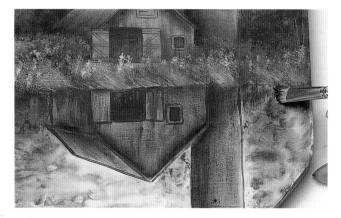

76 Drybrush grasses vertically on the sides of the barn and silo reflections along the shoreline. Use the chisel edge of the ⅜-inch (10mm) blade.

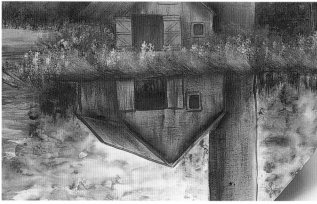

77 Horizontally drybrush Asphaltum on the pond where all of the reflections meet the shoreline, using the tip of the ⅜-inch (10mm) blade.

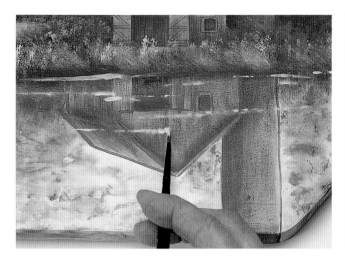

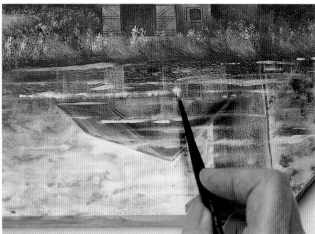

78 Dampen the pond. Paint horizontal stutter strokes to make ripples across the reflections with Blue Mist and the no. 1 liner.

79 Add in a few Yellow Ochre ripples in the same way. Let dry.

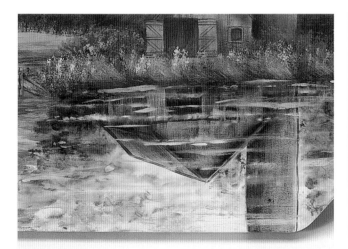

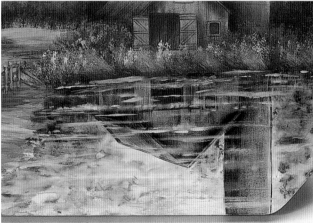

80 Redampen the surface. Add floating leaves using the tip of the ⅜-inch (10mm) blade and coral mix, Cadmium Red and Cherry Red plus Pumpkin along the shoreline. Pull through this application horizontally to soften and flatten using the no. 6 round brush. Let dry.

81 Dampen the pond again and place more ripples in with the floating leaves. Use the no. 1 liner and Blue Mist as before.

Cast Shadows and Green Bushes

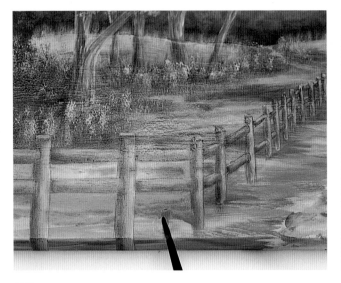

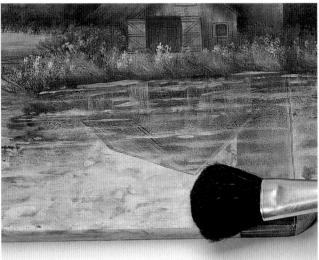

82 Create the cast shadows to the left of each foreground tree and the fence posts using the no. 6 round and thinned Black Plum. Make these transparent shadows fall over the grasses and wildflowers and across the road.

83 Glaze a transparent wash of Midnite Blue over the pond. Soften any streaks with the mop brush. Let dry. A second application may be necessary to cool and darken the pond.

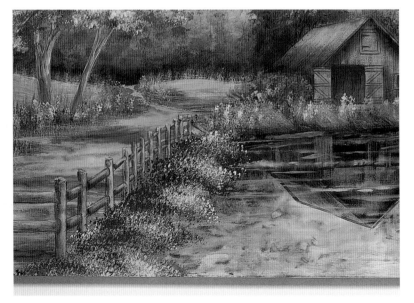

84 Load the high side of the no. 8 halo with Evergreen and tap on the bushes to the right of the fence. Allow the bushes to spray over the base of the fence and over the edge of the pond. Add Antique Green to the tops of these forms, then Cadmium Yellow to highlight in the same way.

85 Add Asphaltum "dirt" between the bushes along the fence in the same way.

Critique

It is time to look at the painting and decide where additional applications should be made. Each of the following numbered areas will improve the final scene and show you how to build each element for a more dimensional look.

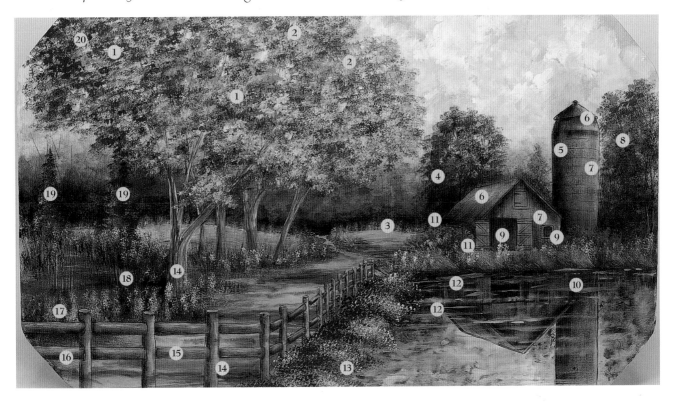

1. Lighten the right side of the tree with more yellows and darken the left side with Cherry Red. Use the tip of the ¾-inch (19mm) blade.

2. Add more Cherry Red and Cadmium Red to the left side of the red trees and Cadmium Yellow and Pumpkin to the right using the tip of the ⅜-inch (10mm) blade.

3. Tap on more Cherry Red bushes and coral mix highlights using the tip of the ⅜-inch (10mm) blade.

4. Highlight the small pine trees with Blue Mist on the tip of the ⅜-inch (10mm) blade.

5. Tap on additional Plantation Pine to enlarge the vines, then Jade Green highlights using the ⅜-inch (10mm) blade tip.

6. Drybrush more Cadmium Yellow sunshine on the structures using the chisel edge of the ⅜-inch (10mm) blade.

7. Drybrush Neutral Grey on the siding of the structures in the same way.

8. Add tints of coral mix to the small red trees using the tip of the ⅜-inch (10mm) blade.

9. Shade inside the door and window with a float of Graphite using the ¼-inch (6mm) angular. Allow to dry and redetail using Graphite and the no. 10/0 liner. Darken the window and door with a thin glaze of Black Plum using the no. 6 round.

10. Paint more Blue Mist and Yellow Ochre ripples. Dry and then glaze with another float of Midnite Blue along the shorelines. Dry again and add a float of Black Plum to darken.

11. Glaze behind the barn and left door using a float of Midnite Blue.

12. Add more floating leaves using the tip of the ⅜-inch (10mm) blade and the coral mix, Cadmium Red and Cherry Red plus Pumpkin along the shorelines.

13. Add more Cadmium Yellow highlights on the green bushes using the no. 8 halo.

14. Float Black Plum to the left of the posts, the base of the rails and the left side of the tree trunks using the ¼-inch (6mm) angular.

15. Reglaze Black Plum shadows across the road and along the left edge using the no. 6 round.

16. The extension of the Midnite Blue wash appears along the left edge, across the bottom of the road and green bushes. Please see no. 20 below.

17. Paint more wildflowers using the chisel edge of the ⅜-inch (10mm) blade.

18. Paint fallen leaves under the trees and along the edge of the road the same as the floating leaves.

19. Paint more boughs to enlarge the two large pine trees using Plantation Pine. Add Blue Mist highlights using the tip of the ⅜-inch (10mm) blade.

20. Apply a thin wash of Midnite Blue along the left edge of the scene. Soften using the mop brush to blend. Start at the yellow tree and follow the left edge over the pine trees and fence.

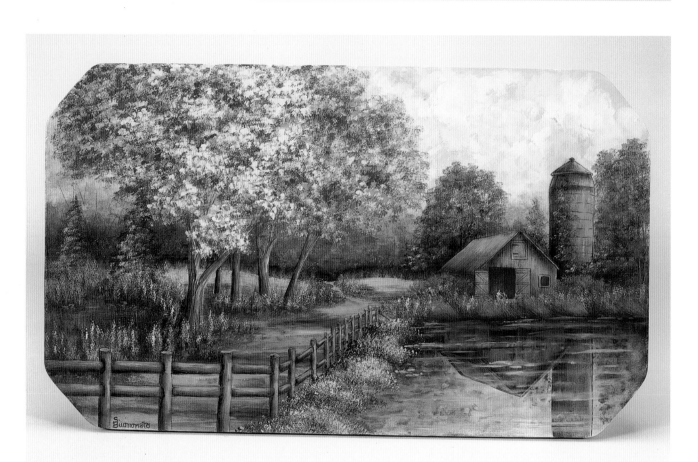

86 In the image above, the suggestions from the Critique on page 101 have been made.

There is no need to varnish the twig base of the bench. However, protect the painted top and edges with several coats of DecoArt DuraClear Satin varnish.

By continuing the painting onto the sides of the surface, the bench is a pleasure to look at from any angle.

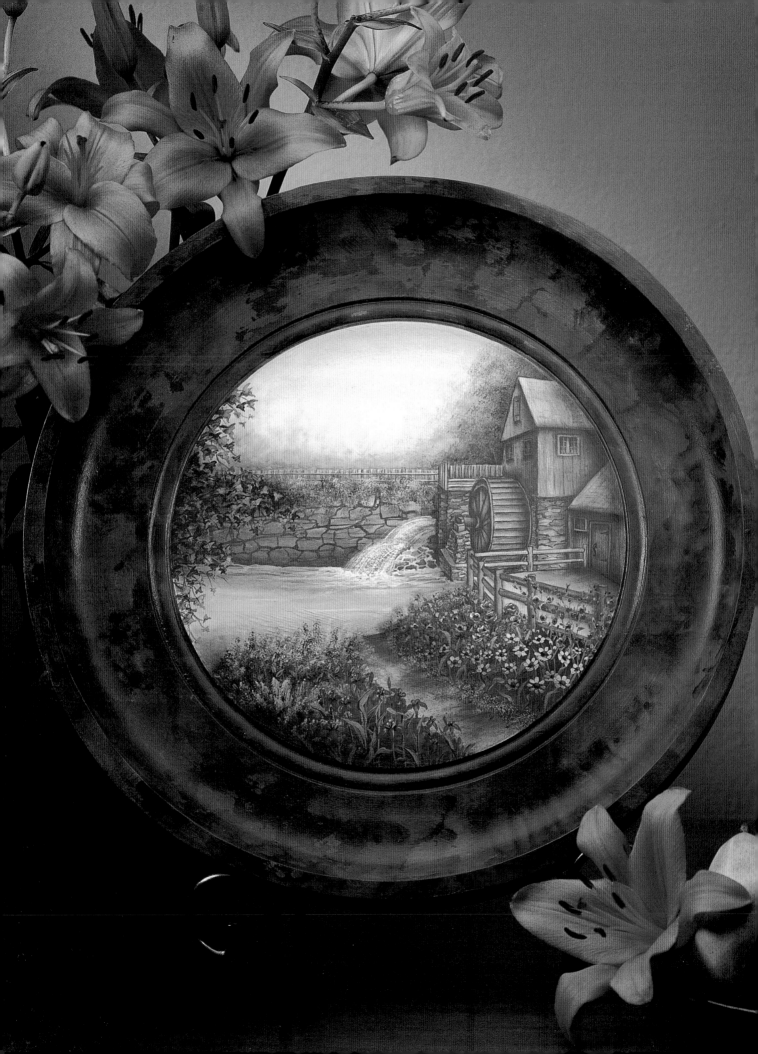

Jenny Grist Mill

The Jenny Grist Mill gives you a wonderful opportunity to combine all the skills you have learned in the previous chapters. Plus, you will see how to paint larger buildings, a waterwheel, colorful flowers, a small waterfall and foreground leaves and branches. I think the most fun and exciting part of this project is the faux tortoiseshell border. Enjoy!

materials

Pale yellow mix = Buttermilk + Yellow Ochre + Multi-Purpose Sealer (2:1:1)

Buttermilk

Yellow Ochre

Blue Mist

Victorian Blue

Light blue mix = Victorian Blue + Buttermilk (1:1)

Deep Midnight Blue

Black Plum

Plantation Pine

Jade Green

Medium green mix = Jade Green + Plantation Pine (1:1)

Yellow-green mix = Cadmium Yellow + Plantation Pine (1:1)

Cadmium Yellow

Orange mix = Cadmium Red + Cadmium Yellow (1:1)

Light orange mix = orange mix + Buttermilk (2:1)

Cadmium Red

Peony Pink

Honey Brown

Raw Sienna

Burnt Sienna

Tan mix = Burnt Sienna + pale yellow mix (1:1)

Dark brown mix = Burnt Sienna + Graphite (1:1)

Graphite

Soft gray mix = Graphite + Buttermilk (1:1)

surface

- 16-inch (41cm) wood bowl/plate with 10-inch (25cm) beaded inset from Wayne's Woodenware

Brushes

- ³/₈-inch (10mm) and ³/₄-inch (19mm) blades
- ¹/₄-inch (6mm), ³/₈-inch (10mm) and 1-inch (25mm) angulars
- 1-inch (25mm) flat
- no. 3 round
- nos. 10/0 and 1 liners
- no. 1 mop
- 2-inch (51mm) foam brush

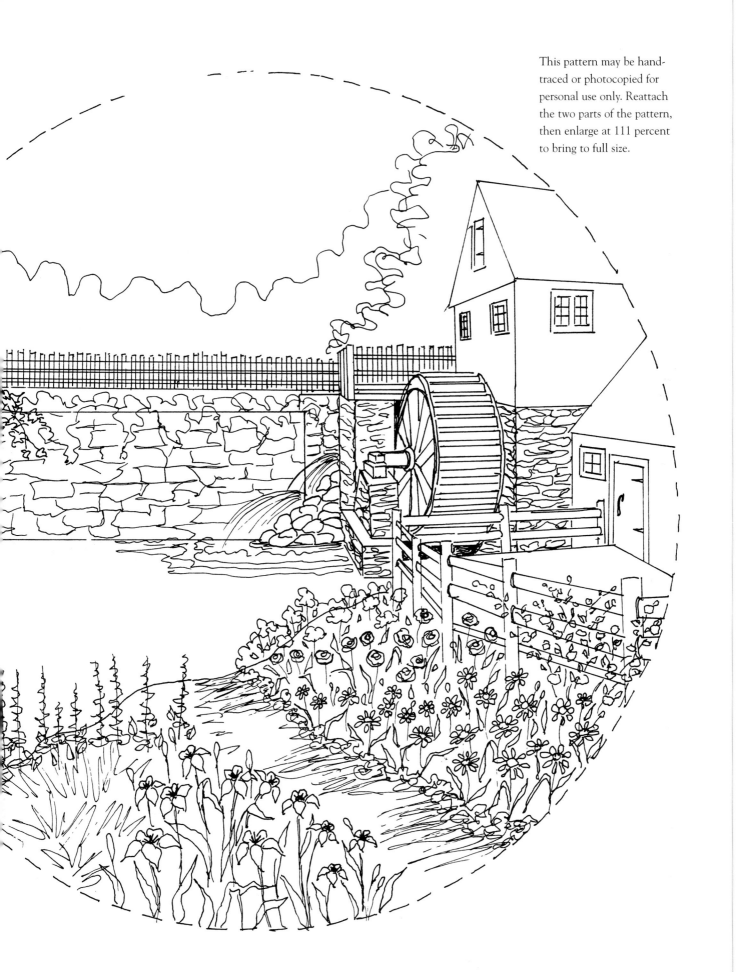

This pattern may be hand-traced or photocopied for personal use only. Reattach the two parts of the pattern, then enlarge at 111 percent to bring to full size.

Preparation and Detailing

1 Sand and seal the surface with Buttermilk + DecoArt Multi-Purpose Sealer (2:1). Let dry. Lightly sand, wipe and reapply. Rub the surface smooth with a piece of brown paper bag. Basecoat the back and rim with Raw Sienna. Transfer the pattern to the 10-inch (25cm) center using gray graphite paper, a ruler and a stylus. At this time, do not transfer the small fence along the horizon line.

2 Dampen the surface. Apply thinned pale yellow mix to the horizon line, and walk it up halfway with the 1-inch (25mm) angular. Rinse the brush, and apply thin Blue Mist to the top and walk it down to meet the yellow. Wipe the brush and blend where the colors meet. Dry and repeat if necessary for a soft sky with equal intensity of both colors. If any sky colors smudged the mill, paint them out using Buttermilk.

3 Paint the negative spaces in the wheel and in the building windowpanes with Graphite using a no. 3 round and a no. 1 liner.

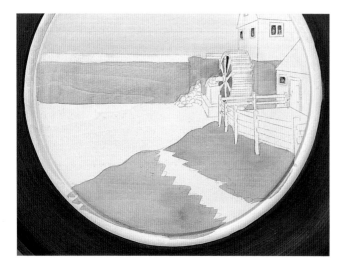

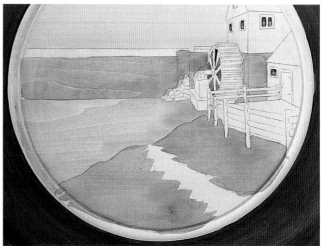

4 Apply a thin wash of Graphite in vertical strokes to all stone walls and supports. Paint the dirt areas under the deck and both sides of the pathway with horizontal strokes using the 1-inch (25mm) angular. You should see the pattern clearly under this application.

5 Apply a thin wash of Blue Mist to the river in horizontal strokes using the 1-inch (25mm) angular.

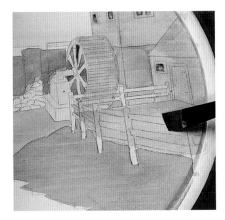

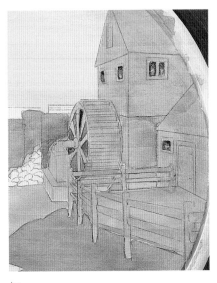

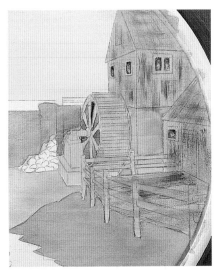

6 With vertical strokes, wash the buildings with pale yellow mix using the 1-inch (25mm) angular. Using the no. 3 round, horizontally wash the deck and wheel paddles using pale yellow mix. Let dry. Repeat the same wash procedure using thin Honey Brown. You should be able to see the pattern through the wash colors.

7 Using the same wash procedure with pale yellow mix and Honey Brown, carefully coat each spoke of the wheel, the axle and the block supports with the no. 3 round brush.

8 Vertically drybrush siding on the buildings with a scant amount of Honey Brown on the chisel edge of the ⅜-inch (10mm) blade. Do the same for the roofs, first horizontally then vertically, to look like wood shingles. Pull horizontal dry-brush strokes across the floor of the deck in the same way.

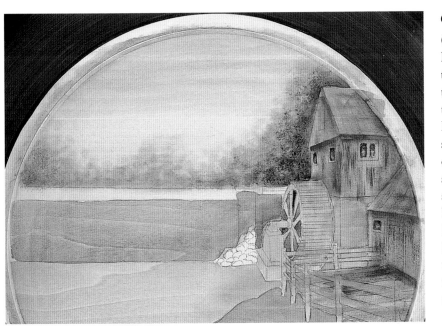

9 Side load Honey Brown on a 1-inch (25mm) flat and shade the buildings. Dampen the sky and dab on the tree-tops with Jade Green using the tip of the ⅜-inch (10mm) blade. Darken the larger tree behind the mill with Plantation Pine. Let dry. Wet the surface and repeat shading to strengthen this tree, keeping the others very soft and distant. Form a triangular-shaped shadow next to the mill at the base of the trees along the horizon line. Let dry. Remoisten and add more Plantation Pine leaf forms on the large tree and Yellow Ochre highlights to the top using the tip of the ⅜-inch (10mm) blade.

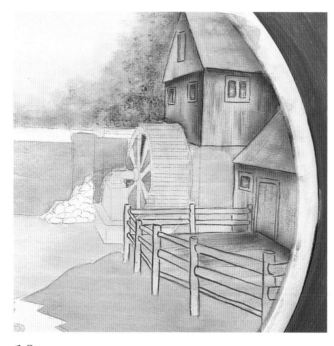

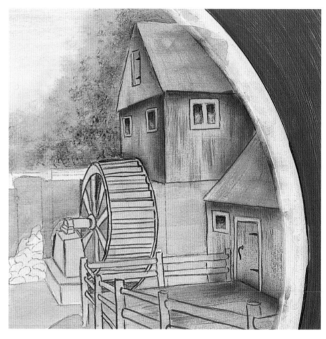

10 Dampen the surface and shade the same areas of the buildings as in step 9 with Burnt Sienna. Use a side-loaded ⅜-inch (10mm) angular. Paint all the detailing on the deck, fencing, buildings, framework and edges with Burnt Sienna and the no. 10/0 liner brush.

11 Paint Graphite hinges and a door latch on the buildings using the no. 10/0 liner. Shade the tops of the windowpanes with a side load of Graphite on the ¼-inch (6mm) angular. Now detail the windows and wheel with Graphite linework. Add Yellow Ochre framework around each window and windowpane. Detail the wheel paddles, spokes, axle and support blocks with Graphite linework.

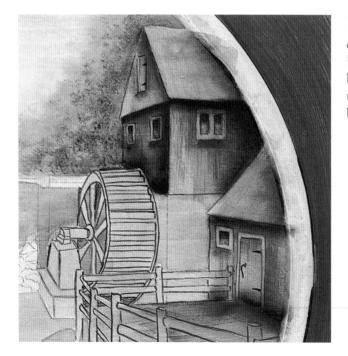

12 Shade around the framework of the windows and the door with two coats of Burnt Sienna side loaded on the ¼-inch (6mm) angular. Intensify the shading on the buildings with dark brown mix (Burnt Sienna + Graphite) to darken all shadows. Remember to dampen the surface before shading.

Wheel and Fence

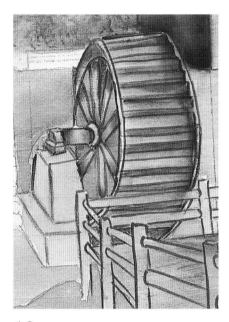

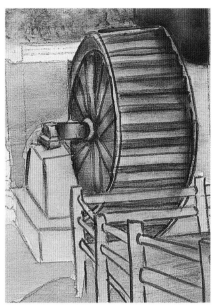

13 Shade the paddles, spokes, axle and blocks with a side load of Burnt Sienna on the ¼-inch (6mm) angular.

14 Shade the axle and next to the wheel edge of the paddles with the dark brown mix. Use the same procedure and brush as was used in step 13.

15 Darken the same areas with Graphite side loaded on the ⅜-inch (10mm) angular.

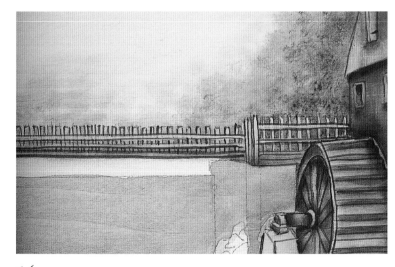

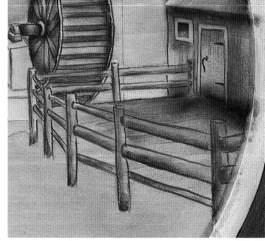

16 Transfer on the small fence using a ruler, gray graphite paper and a stylus. Paint each post and rail with pale yellow mix using the no. 10/0 liner brush. Dampen the surface and anchor the fence to the wall by shading across the base with a side-load float of Burnt Sienna on the ⅜-inch (10mm) angular. Define the posts and rails with Burnt Sienna linework using the no. 10/0 liner.

17 Dampen the surface. Shade the bottom of the rails, left side and base of each post with thinned Honey Brown using the no. 3 round. Let dry. Dampen the surface and shade again with a side load of Burnt Sienna on the ¼-inch (6mm) angular. Detail the posts and rails with Burnt Sienna linework using the no. 10/0 liner.

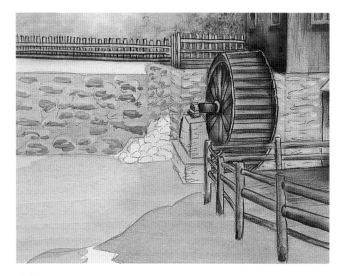

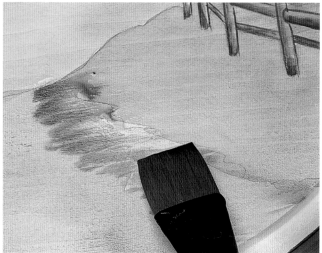

18 Trace on the stone pattern using gray graphite paper and a stylus. Dab pale yellow mix on the rocks using the no. 3 round brush. Now dab Honey Brown to the bottom of the rocks for shading with the no. 3 round.

19 Apply pale yellow mix to the pathway in horizontal strokes using the 1-inch (25mm) angular. Let dry. Dampen the pathway and side-load float Honey Brown along both sides using the 1-inch (25mm) angular and horizontal zigzag strokes. Let dry. Shade again with Burnt Sienna, but apply to the left edge only.

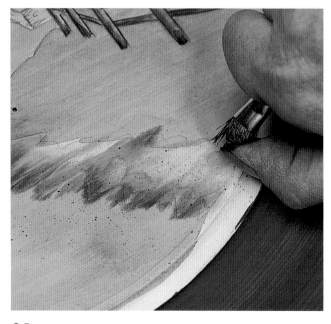

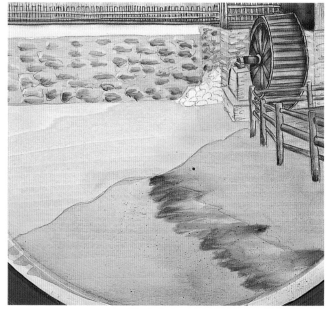

20 Spatter the pathway with the chisel edge of the ⅜-inch (10mm) blade loaded with thinned Burnt Sienna.

21 Darken the shading on the rocks and pathway with dark brown mix as previously instructed in steps 18 and 19.

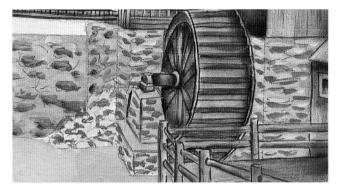

22 Paint the stones on the mill stone walls, sluiceway walls, axle foundation and waterfall rocks with tan mix (Burnt Sienna + pale yellow mix). To form smaller and flatter stonework, use the no. 3 round brush in short, horizontal strokes. Keep the waterfall rocks rounded as shown on the pattern.

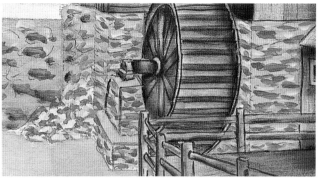

23 Add Yellow Ochre stones in the same way. With soft gray mix (Graphite + Buttermilk) paint randomly placed stones, then shade on the waterfall rocks with the no. 3 round.

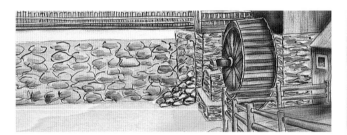

24 Detail the stones with the no. 10/0 liner and Graphite. Also detail the distant stone wall in the same way using Burnt Sienna.

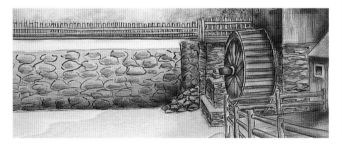

25 Dampen the surface and float Graphite side loaded on the ⅜-inch (10mm) angular to form the corners on both sides of the sluiceway, on the left side of each corner of the walls, on the axle foundation and at the base of the waterfall rocks. Repeat at the base of the mill and distant fencing next to the wheel and mill. Let dry. Moisten the surface and side-load float Burnt Sienna over the corners of the stone walls on the right side using the 1-inch (25mm) angular.

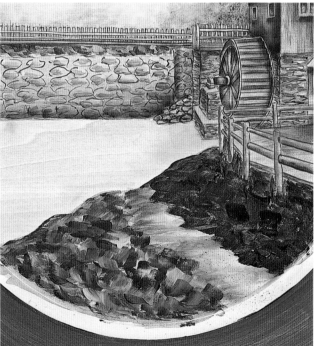

26 Paint choppy strokes in the dirt area on top of the distant stone wall under the distant fencing using the ¼-inch (6mm) angular. First apply Burnt Sienna, then Yellow Ochre and lastly Graphite. Repeat this procedure using the ⅜-inch (10mm) angular for the left foreground dirt next to the pathway. Paint Graphite in the dirt area under the deck with choppy strokes in the same way. Fill in using dark brown mix in the remaining area on the right side of the pathway in the same way.

27 Dampen the surface. Paint the ripples with horizontal stutter strokes using thinned Deep Midnight Blue and the no. 3 round. Let dry.

28 Redampen and side-load float warm tints of Yellow Ochre in the center of the river using a 1-inch (25mm) angular. Next, float Burnt Sienna at the base of the stone walls and waterfall rocks for reflections. Let dry.

29 Moisten again and place Buttermilk and Blue Mist horizontal ripples on the river at the base of the walls and waterfall rocks. Use the no. 1 liner brush. Let dry.

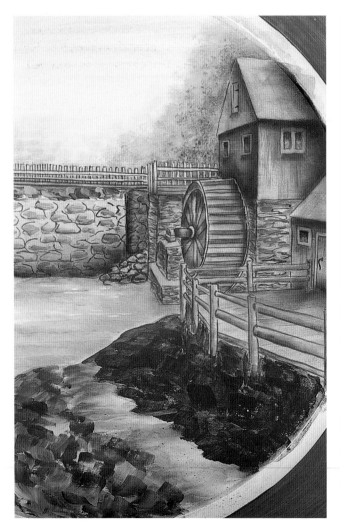

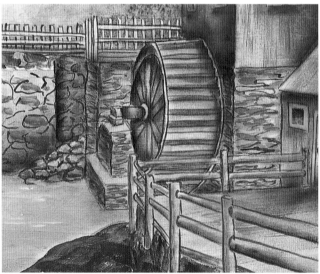

30 **(Left)** Wet the surface again and side-load float Deep Midnight Blue at the bottom of the river next to the pathway and flower beds. Use the 1-inch (25mm) angular. Float Black Plum over the left side of the buildings and on the right side of the roofs to separate in the same way.

31 **(Above)** Darken the sluiceway opening with a Black Plum wash using the no. 3 round. Shade the wheel spokes using the ¼-inch (6mm) angular, and shade the left sides of the corners of the stone walls with a side load of Black Plum using the ⅜-inch (10mm) angular.

Waterfall

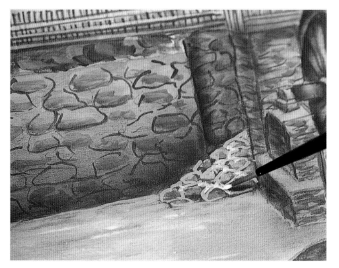

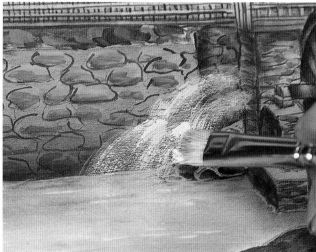

32 First darken and dull the distant stone wall with a thin wash of Burnt Sienna using the 1-inch (25mm) angular brush. Paint trickles of water over the rocks at the base of the sluiceway using the no. 1 liner and Blue Mist. Highlight with Buttermilk.

33 Load Blue Mist on the tip of the ⅜-inch (10mm) blade and tap on your palette. Make the water shoot out of the sluiceway opening above the rocks by dragging your dry brush. Add Buttermilk in the same way to highlight the left side of the waterfall. Repeat this procedure to spray water over the rocks at the base, only in much smaller, individual applications. Do not lose the rocks by painting too much water over them.

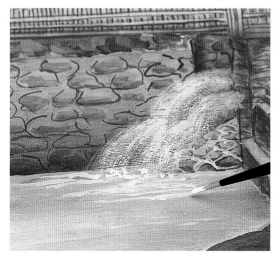

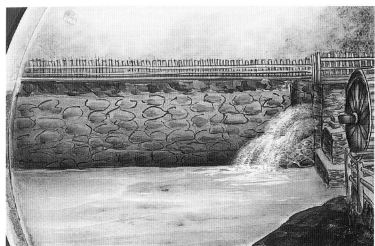

34 Add ripples at the base of the rocks first using Blue Mist then Buttermilk. Use the no. 1 liner brush.

35 Dampen the surface and darken shadows with a side load of thinned Deep Midnight Blue along the left edge of the waterfall on top of the walls, using the ⅜-inch (10mm) angular. Also, darken the base of the distant stone wall and waterfall rocks. Repeat the shading at the base of the river next to the left flower bed and the pathway with a float of Deep Midnight Blue using the 1-inch (25mm) angular.

36 Form the delicate shrubs with Jade Green, then add Plantation Pine to the base. Now highlight using pale yellow mix on the top. Use the tip of the ⅜-inch (10mm) blade for all colors. Allow the shrubs to trail down over the stone wall in an irregular pattern.

37 Load the chisel edge of the ⅜-inch (10mm) blade with Jade Green, then tip the high corner in pale yellow mix and the low corner in Plantation Pine. Tap on the palette to lightly blend.

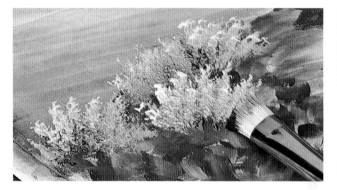

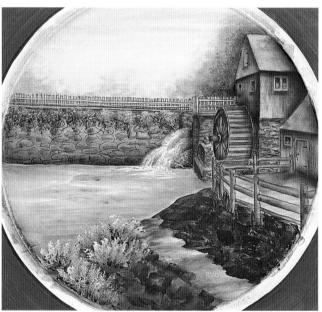

38 (Above Left) Form fan-shaped shrubs in the foreground starting with the two in back and finishing with the larger two in front. The pale yellow mix is facing up when you tap on this application. Be sure to leave plenty of dirt showing between the strokes when forming the shrubs.

39 (Above Right) Shade next to the mill on top of the large tree with a float of Black Plum on the ⅜-inch (10mm) angular. Darken the water at the sluiceway openings and on the shadows across the pathway. Glaze the mill stone wall, paddles and dirt area on the left with very thin Burnt Sienna applied with the ⅜-inch (10mm) angular. Also, glaze the foreground fence posts and rails to darken with thin Burnt Sienna using the no. 3 round.

40 (Right) Enhance the waterfall ripples with Blue Mist on the no. 1 liner. Highlight in the same way using Buttermilk.

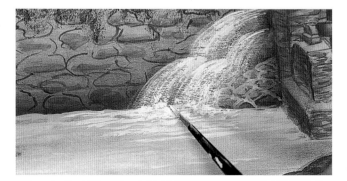

41 Dab Plantation Pine with the tip of the ⅜-inch (10mm) blade, then paint stems with Jade Green tipped with Plantation Pine using the no. 10/0 liner. Add a few small inside one-stroke leaves in the same way coming off the stems using the no. 3 round. Form the round shapes of the flowers with orange mix (Cadmium Red + Cadmium Yellow) dabbed on using the tip of the ⅜-inch (10mm) blade.

Next add delicate dabs of light orange mix (orange mix + Buttermilk) to the tops of each flower. Shade the bottoms in the same way using a tad of Black Plum.

42 Paint the stems and leaves of the peonies as you did for the orange filler flowers, except make them slightly larger. Using the no. 3 round, paint outside one-stroke petals using Peony Pink to form each flower.

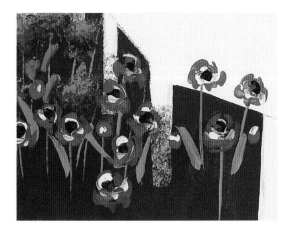

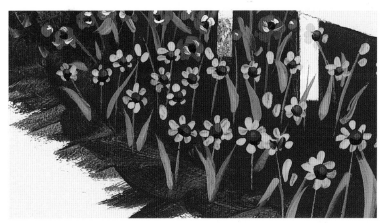

43 While still wet, add Buttermilk overstrokes to the top and a Black Plum center using the no. 1 liner. Also paint single-stroke buds in the same way.

44 Paint the stems and long leaves with Jade Green tipped with Plantation Pine using the 10/0 liner. Paint outside one-strokes for black-eyed Susan petals and buds using Cadmium Yellow. Dot the centers with Burnt Sienna using the no. 1 liner brush. Make the front Susans slightly larger.

Highlight a few leaves with yellow-green mix (Cadmium Yellow + Plantation Pine). Finish the centers with a Black Plum dash at the base and an orange mix dot to highlight using the no. 10/0 liner.

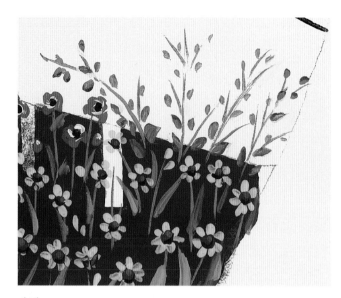

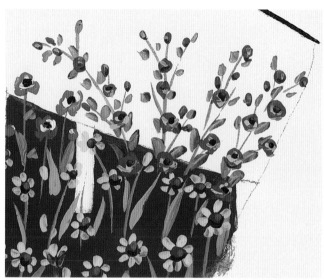

45 Start by painting the vines with Jade Green tipped with Plantation Pine on the no. 10/0 liner. With the no. 1 liner, add tiny inside one-stroke leaves off the vines. Paint the leaves smaller at the ends of the vines.

46 Form the round-shaped rosebuds with tiny Cadmium Red one-stroke buds. Wet-on-wet, add Yellow Ochre over-strokes and Black Plum dot centers for each open rose and a dash at the base of each bud with the no. 10/0 liner.

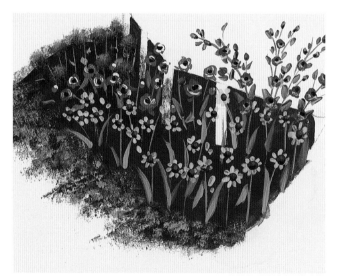

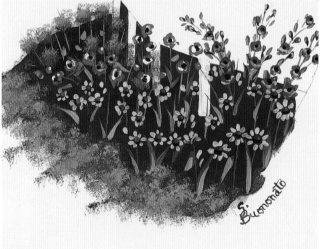

47 Delicately dab Plantation Pine at the base of the flower bed, then highlight the top with Jade Green using the tip of the ⅜-inch (10mm) blade.

48 Add tints to the flowers at the base with the yellow-green mix and dry well. Delicately dab on Victorian Blue with the blade.

Add Deep Midnight Blue to the bottoms and light blue mix (Victorian Blue + Buttermilk) to the tops.

Left Flower Bed

49 Paint the stems and small leaves the same as you did for the orange filler flowers in step 41.

50 Begin to form the conical shape with Victorian Blue. These will grow higher than the shrubs and pop over the river's edge.

51 Add the same shading and highlight colors as you did for the blue filler flowers, but keep the conical shape. Not every flower needs a highlight, so some will appear darker and behind others.

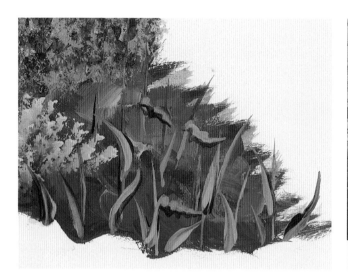

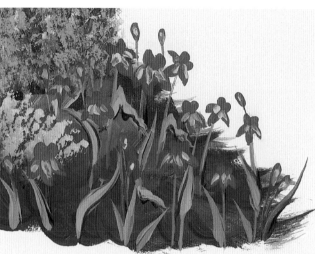

52 Paint the stems and leaves the same as you did for the black-eyed Susans in step 44.

53 Paint the daylilies with outside one-strokes using the orange mix and the no. 3 round for each flower. Paint the daylilies next to the pathway first and make them smaller than the other daylilies. Make the flowers to the left and the bottom get progressively larger. Add Cadmium Yellow overstrokes only to the front petals while the orange paint is still wet. Paint the buds in the same way.

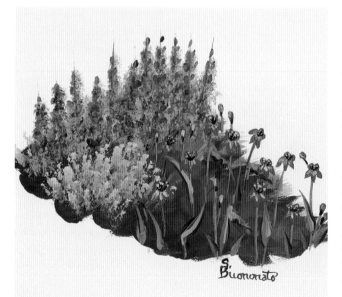

54 (**Left**) Paint the flower centers with Black Plum linework, pulled out in a fan shape from the center. Let dry and add Cadmium Yellow stamens and dots to the top of the fan shape.

55 After the flowers are complete, create sun streaks by dampening the surface with clean water and the 1-inch (25mm) flat (see finished art on page 123). Side load the 1-inch (25mm) angular with Black Plum and shade the flowers in the right flower bed next to the pathway. While still wet, wipe off the Black Plum with a clean no. 3 round brush in a diagonal stroke. You can also do this on the pathway. Leave the rest of the flowers in the shade. Do the same thing to the left flower bed. Leave the flowers next to the edge of the pathway light. Wipe off the closest flowers and leave the back flowers darker to create depth and shadows. Do not lose the sun streaks on the pathway!

Foreground Leaves and Branches

56 Behind the foreground leaves and branches, paint a crescent-shaped shadow over the distant stone walls, fencing, shrubs and river (shown here without the rest of the painting). To paint this, dampen the surface, then side load Plantation Pine on the 1-inch (25mm) angular. Walk the brush out from the curved edge and form the crescent shape. Soften the shadow with the no. 1 mop.

After the shadow has dried, transfer on the branches and leaves with gray graphite paper. Paint all the light leaves with medium green mix (Jade Green + Plantation Pine). Paint all the dark leaves Plantation Pine using the no. 3 round.

57 Shade the left side and tops of the light leaves with a side load of Plantation Pine on the ¼-inch (6mm) angular. Add tints of yellow-green mix to a few of the leaves on the top right side of each leaf cluster in the same way. Highlight the dark leaves with a side load of medium green mix to the centers, and detail the edges and center veins of all leaves with Plantation Pine linework.

58 Make the Honey Brown branches using the no. 1 liner, then detail with the dark brown mix using the no. 10/0 liner. Tuck some shadows under the inner leaves using Plantation Pine side loaded on the ¼-inch (6mm) angular. Float Black Plum under the leaves along the curved edge for dark shadows. Glaze over the foreground leaves and branches with an additional layer of Plantation Pine crescent shadow. Dry, then glaze the center of the crescent with Black Plum in the same way. Remember to use the no. 1 mop to soften and fade off the edges of the two glaze applications.

Faux Tortoiseshell Technique

59 Basecoat the beaded rim, sides and back of the bowl with two coats of Raw Sienna using the 2-inch (51mm) foam brush. Dampen the surface and while wet, brush on dark blotches with thinned Black Plum using the 1-inch (25mm) flat. Work in one area at a time for better control. Let dry.

Drybrush on additional Black Plum with the sides of the ¾-inch (19mm) blade, working in a slip-slap motion. Leave dark marks on the surface.

With the same technique, add Honey Brown dry brush marks between the dark areas. Dry the surface well.

60 Moisten with water and apply Black Plum blotches. Let them drip, run and move while you dry the surface with a hair dryer on medium heat.

61 Wet the surface again and paint blotches of Honey Brown for highlights. Let the paint run as you dry with the hair dryer.

62 After the surface has dried, warm and soften with an overall glaze of Burnt Sienna. If desired, apply a second layer of Burnt Sienna for deeper color.

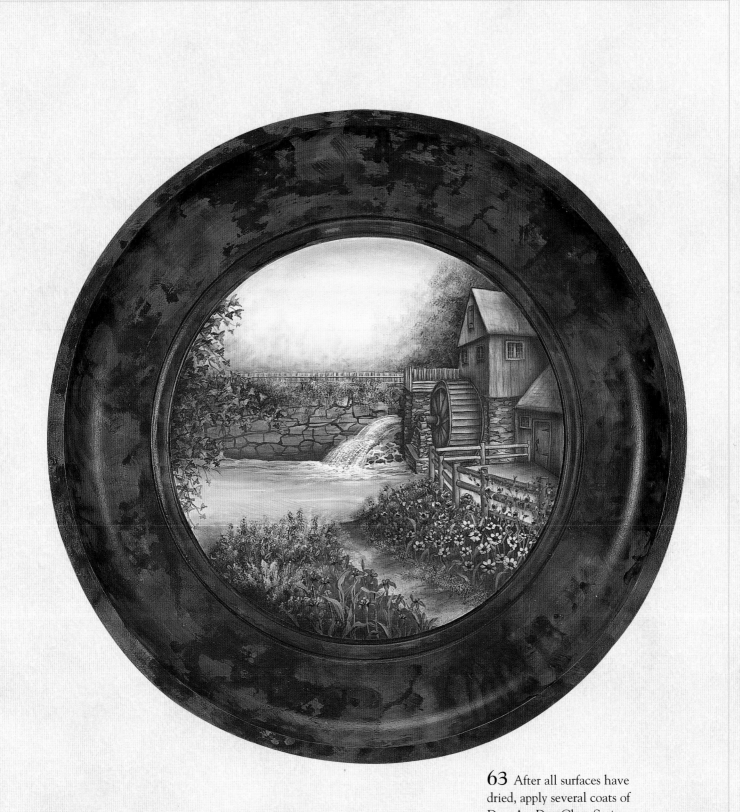

63 After all surfaces have dried, apply several coats of DecoArt DuraClear Satin varnish to protect the piece.

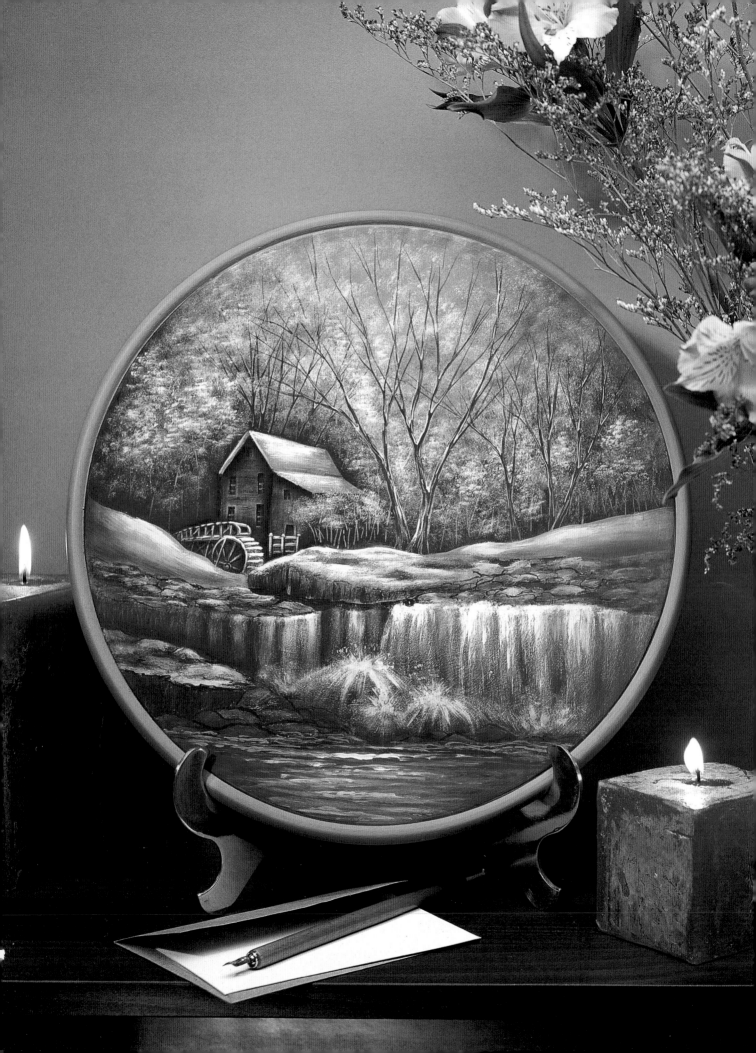

Project Six

Glade Creek Mill

This cool-tone painting is a departure from the other projects. We start out with a cool background color and then apply snowy applications to convey a cold winter's day. This natural scene teaches you how to paint a weathered mill and a snowy forest, plus splashing, cascading water flowing over cliffs and rocks. The final glazing techniques further enhance the icy scene. This project completes our journey, and I truly hope you have enjoyed the trip. Happy landscape painting!

materials

 Hi-Lite Flesh

 Blue/Grey Mist

Plum

Black Plum

Burnt Sienna

Asphaltum

Deep Midnight Blue

Graphite

Soft Black

Surface

- 13-inch (33cm) wood scoop plate with beaded outer edge from Viking Woodcrafts, Inc.

Brushes

- $^3/_8$-inch (10mm) blade
- $^3/_8$-inch (10mm) crown
- 1-inch (25mm) flat
- $^1/_8$-inch (3mm), $^1/_4$-inch (6mm), $^1/_2$-inch (12mm) and 1-inch (25mm) angulars
- nos. 10/0 and 1 liners
- nos. 3 and 12 rounds

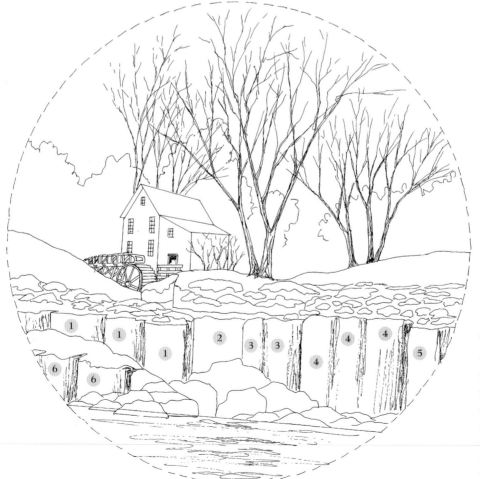

This pattern may be hand-traced or photocopied for personal use only. Enlarge first at 200 percent, then again at 132 percent to bring to full size. The numbers on the pattern are to identify the cliffs and are used beginning in step 25.

Mill and Horizon Line

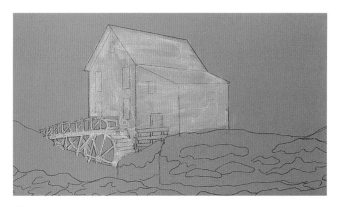

1 Lightly sand, wipe and basecoat using Blue/Grey Mist + Multi-Purpose Sealer (2:1). Repeat the procedure. Trace on the pattern using gray graphite paper, a ruler and a stylus, being careful of the mill's wheel construction. Do not trace on the trees or ripples on the river.

2 Place a thin wash of Hi-Lite Flesh on the mill using the ¼-inch (6mm) angular. You should see the pattern lines through this thin application.

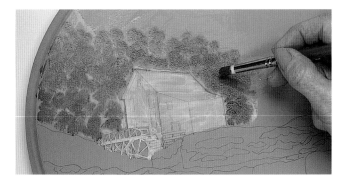

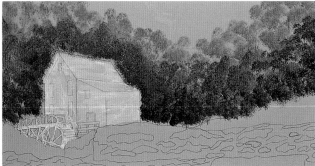

3 Place a thin wash of Blue/Grey Mist on the sky with a 1-inch (25mm) flat. Dab on Plum using the ⅜-inch (10mm) crown. Start at the horizon line and work up into the wet wash. Continue this across the horizon line and around the mill.

4 Dampen the surface and add Black Plum to the horizon line. Walk the paint two-thirds of the way over the Plum areas to form darker background trees.

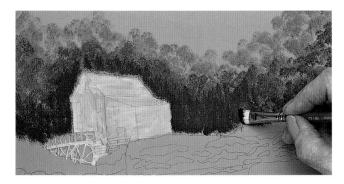

5 Using the chisel edge of the ⅜-inch (10mm) blade and Black Plum, dab vertically to darken and create vertical tree shadows.

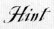

Hint

I use Hi-Lite Flesh 90 percent of the time instead of white for the clouds, snow, water reflections, etc. Occasionally I will use white to highlight on top of the Hi-Lite Flesh applications.

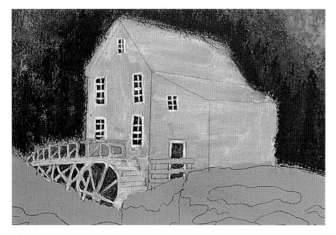

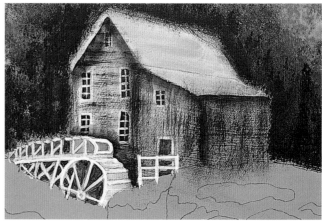

6 Paint the windows with Soft Black using the ⅛-inch (3mm) angular. Also, paint the negative spaces on the wheel and between the spokes and structural beams using the no. 3 round. Paint the door Asphaltum shaded Soft Black at the top using a side-loaded ¼-inch (6mm) angular. Outline the windows, door and windowpanes with Hi-Lite Flesh and the no. 10/0 liner.

7 Base in the fence, wheel and framework with Hi-Lite Flesh using the no. 10/0 liner. Using the chisel edge of the ⅜-inch (10mm) blade, horizontally drag thinned Asphaltum on the left-hand building for the siding. Repeat the same process vertically on the right-hand building. Repeat the same process using Soft Black and allowing the Asphaltum to be seen. Dampen the surface and shade Soft Black on the buildings using the side-loaded ½-inch (12mm) angular. Paint shadows under the eaves, on the right side of the front corners and next to the wheel construction.

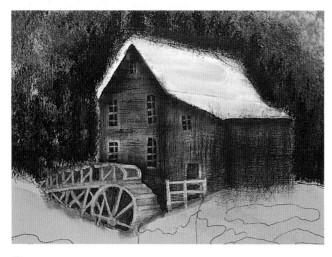

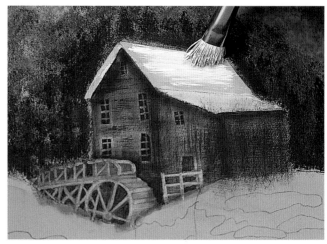

8 Wash over the fence, wheel and framework with thin Asphaltum to tint. Do the same over the buildings using the ½-inch (12mm) angular.

9 Paint the snow on the roofs with Hi-Lite Flesh, pulling the chisel edge of the blade horizontally. Clean the outside edges of the roofs and buildings with Black Plum linework on the no. 10/0 liner. Apply snow to the eaves, fence and wheel construction with Hi-Lite Flesh on the same liner. See the photo with step 10 for the completed linework.

Background Trees

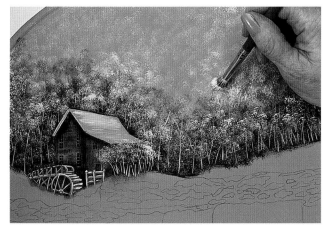

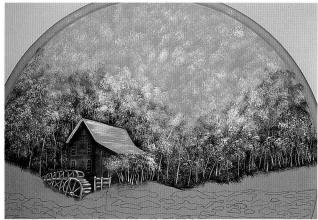

10 Paint Hi-Lite Flesh linework trunks and branches, then dab snow on the treetops using the ⅜-inch (10mm) crown. This is a very sparse application; it should look delicate and lacey. Paint the bushes at the base of these trees with slightly thicker linework branches and more snow on the tops.

Here the trees are complete through step 10.

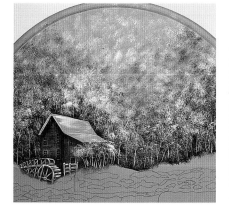

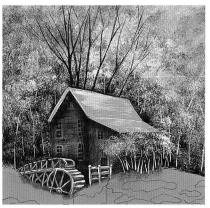

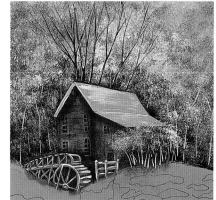

11 Break up the gray-and-white background by adding Plum to the snowy trees. Repeat the same process as in step 10. Use a dry-brush application and tap off the excess paint on the palette.

12 Trace on the trees located behind the mill, and pull thick trunks into the tree branches with Black Plum using a no. 1 liner.

13 Detail the Black Plum tree trunks and branches with Hi-Lite Flesh snow linework using the no. 10/0 liner. The snow will rest mainly in the V areas of branches and along the trunks.

Hint

If you have made your tree trunks too wide, go back with Hi-Lite Flesh and blend them into the snowy area.

14 Transfer two large trees next to the mill and three smaller trees to the right with gray graphite paper and a stylus. Paint the larger trunks and branches with Graphite using the no. 3 round, then use the no. 1 liner and no. 10/0 liner for the smaller branches and twigs.

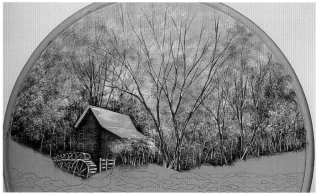

15 Apply Hi-Lite Flesh snow in the same way using the no. 10/0 liner for the small trees and the no. 1 liner for the larger trees. Highlight the bark on the two large tree trunks with Hi-Lite Flesh linework. If necessary, clean up the edges of the fence, the wheel construction and the framework with Asphaltum linework.

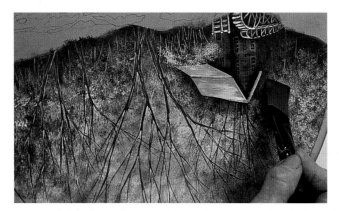

16 Dampen the surface to help create depth and dimension to the mill and trees with a side-load float of thinned Deep Midnight Blue. Using the 1-inch (25mm) angular, float the color across the tree bottoms next to the horizon line and around the mill. Be sure to work on a flat surface so the color will not run or drip. It is also better to turn the plate upside down to better see the application. Pat and pull the color into the snowy tree area and fade off. Repeat this shading at the base of the snowy bushes in back of the mill and across the bottom of the wheel construction and fence using a side-loaded ¼-inch (6mm) angular. Also, separate the roof sections with Deep Midnight Blue shading in the same way.

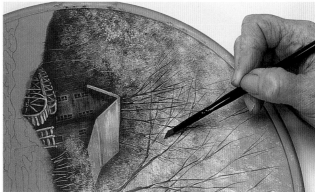

17 Form a triangular shadow next to the left side of the mill using Graphite side-loaded on the 1-inch (25mm) angular. Pull this shadow up the left side of the mill, stopping at the peak of the roof. Let dry. Dampen the surface and tint the snowy treetops, the right side of the roofs and the wheel construction with a side load of thinned Burnt Sienna using the ¼-inch (6mm) angular. This should be a soft color tint.

Hint

When transferring the pattern for the trees, use white graphite paper for the bottom 1½ inches (3.8cm). This will help you see the trunks against the dark background.

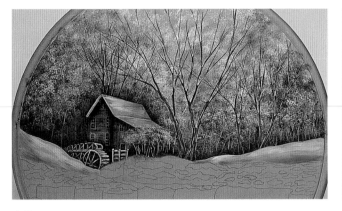

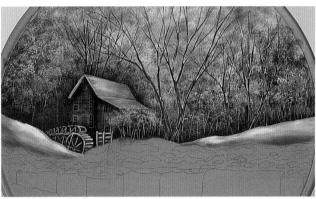

18 Base the snowbank area with thinned Blue/Grey Mist and the 1-inch (25mm) angular. While wet, drag Hi-Lite Flesh across the tops using the ⅜-inch (10mm) crown. Shade the bottom with Black Plum in the same way. Let dry.

19 Dampen the surface and add Graphite to the shadows as previously done with the Black Plum. Let dry. Highlight the tops of the snowbanks again with Hi-Lite Flesh using the chisel edge of the ⅜-inch (10mm) blade.

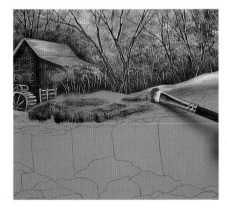

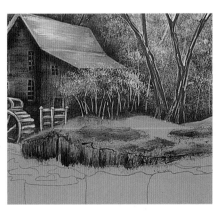

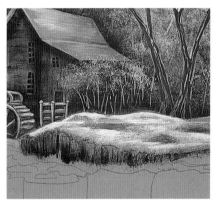

20 Base the ledge vertically with Graphite using the chisel edge of the ⅜-inch (10mm) blade. Shade with Soft Black in the same way to create vertical streaks. Pull Blue/Grey Mist highlights across the top, and pull down using the chisel edge of the blade. Paint the horizontal patches of rock showing above the ledge in the same way using the tip of the ⅜-inch (10mm) blade.

21 Define the separation between the ledges with vertical linework of Black Plum using the no. 10/0 liner.

22 Using the tip of the ⅜-inch (10mm) blade, horizontally drag on Hi-Lite Flesh snow to the tops of the ledge and between the dark patches.

Hint

To check the integrity of the shading, moisten the surface with clean water. This will act like a varnish. You can then add shading as necessary.

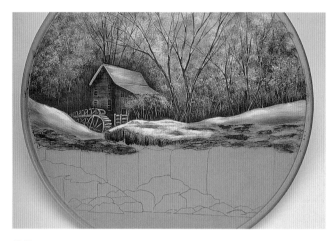

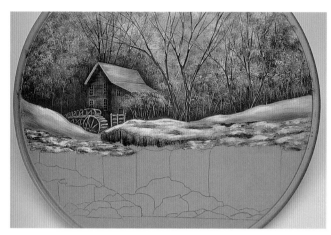

23 Base the rocks to the right of the rock ledge with Blue/Grey Mist. Shade with Graphite by dabbing and horizontally dragging with the tip of the ⅜-inch (10mm) blade. Tint these rocks with Asphaltum to warm by dry brushing in the same way. Base the rocks to the left of the rock ledge mostly with Soft Black, and horizontally shade using Black Plum and Graphite. Detail the rock forms using Black Plum and the no. 10/0 liner.

24 Add snow to the tops of each rock by horizontally dragging Hi-Lite Flesh on the tip of the ⅜-inch (10mm) blade. The snow should be more sparse and splotchy than on the rock ledge.

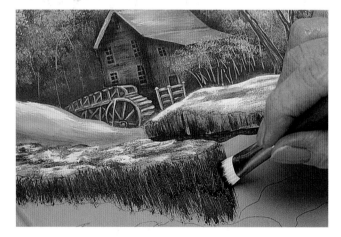

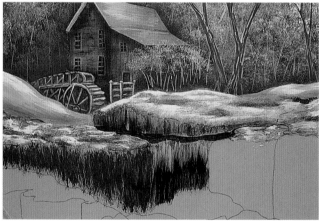

25 Before painting the cliffs, fill in the negative space at the base of the rock ledge to separate the two areas using Soft Black and the no. 3 round. Please look at the cliff numbers indicated on the pattern on page 126. Paint cliff one Soft Black with Graphite at the top and highlights of Blue/Grey Mist. Using the same procedure as you did with the rock ledge, form a vertical cliff using the chisel edge of the ⅜-inch (10mm) blade. The light color to the top indicates the light source and can be painted using the tip of the ⅜-inch (10mm) blade.

26 Cliff two is located to the right of cliff one. Paint this cliff with the same vertical strokes using Soft Black at the base and Blue/Grey Mist at the top.

Hint

The cliffs will be
lighter toward the top
at the light source.

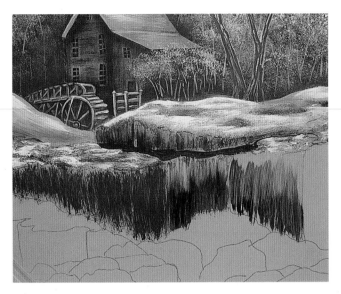

27 Shade cliff three with the same vertical strokes using Asphaltum at the base and Blue/Grey Mist to the top.

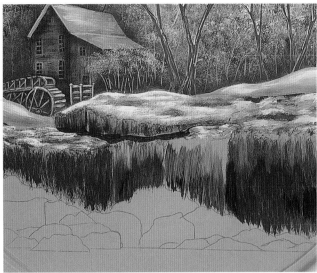

28 Paint cliff four with Asphaltum shaded with Graphite and Blue/Grey Mist to the top.

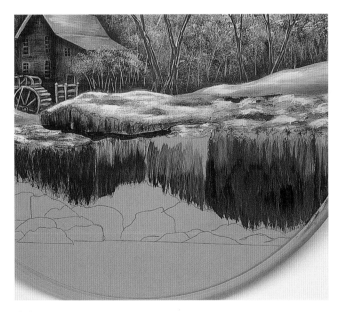

29 Paint cliff five slightly lighter by using less Graphite.

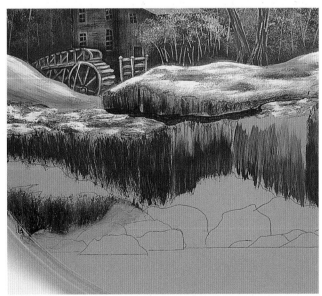

30 Cliff six is located at the bottom left, under cliff one, and is very dark. Use the same colors as you used for cliff one with a small amount of Asphaltum tint.

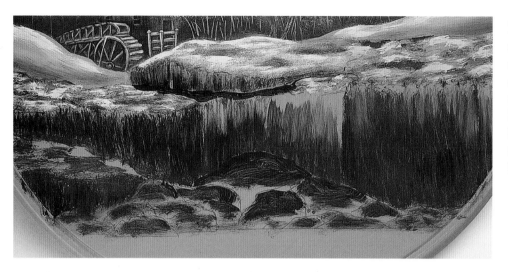

31 Before painting the rocks, clean up the bottoms of the cliffs by horizontally dragging Graphite on the tip of the ⅜-inch (10mm) blade. Base each rock with horizontal strokes using the tip of the ⅜-inch (10mm) blade and Asphaltum.

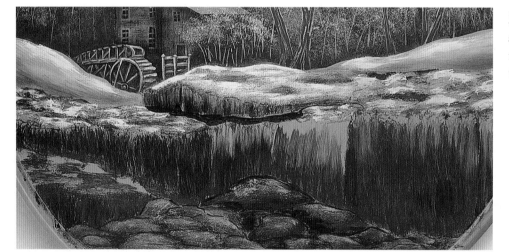

32 Shade Graphite in the same way at the base of each rock. Use Soft Black between the rocks to separate.

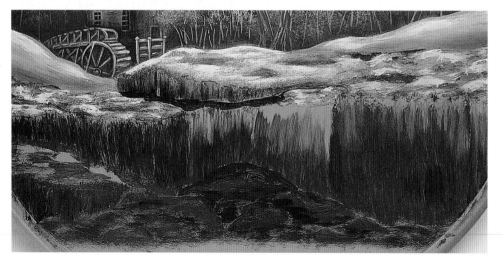

33 Highlight the tops with Blue/Grey Mist using the tip of the ⅜-inch (10mm) blade. Separate and detail the rocks with Black Plum linework using the no. 10/0 liner.

Waterfall

34 The waterfall cascades over all the cliffs except cliff six. Start by placing dabs of Blue/Grey Mist on the top of cliff one, two and three using the tip of the ⅜-inch (10mm) blade. Allow the cliff colors to show between this paint application.

35 Turn the brush over and use the chisel edge to drag the paint down the cliffs. Create the water with dry-brush strokes. Allow the dark cliffs to show beneath and between the water streaks. The color should be stronger at the top and fade as it is pulled down.

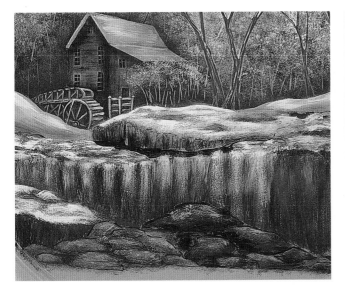

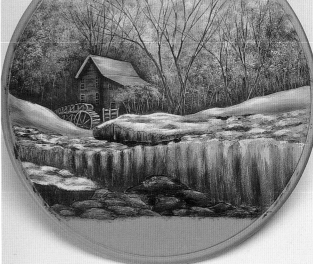

36 Add a sparse layer of Hi-Lite Flesh at the top of the heavier streaks, and pull down in the same way. Keep the highlights mostly to the tops, and keep the lower streaks more blue. Add a little more Hi-Lite Flesh for a stronger highlight on the top of a few of the larger streaks. Add snow to the rocks on top of cliff six with horizontal streaks of Hi-Lite Flesh on the tip of the ⅜-inch (10mm) blade.

37 Paint the rest of the waterfall over cliffs four and five with the same technique as was in the previous cliffs. Add a sparse layer of Blue/Grey Mist to the Hi-Lite Flesh.

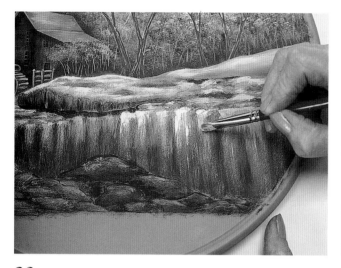

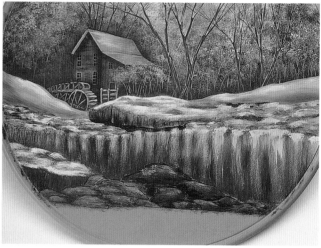

38 Add more Hi-Lite Flesh highlights to the top edge of cliffs three, four and five using the tip of the ⅜-inch (10mm) blade. Turn the blade sideways and drag down with the tip to leave a stronger streak of paint. If you turn the plate sideways, you can see the streaks as they are being pulled down.

Here the waterfall is complete through step 38.

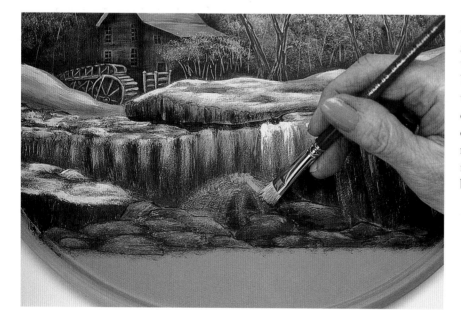

39 Tap the splashes on the foreground rocks with Blue/Grey Mist using the tip of the ⅜-inch (10mm) blade. Turn your brush over and pull the chisel edge over the rock in a curving, fluid motion. Remember to curve the strokes in the shape of the rock, some to the left and right, leaving the color of the rocks showing between the splashes.

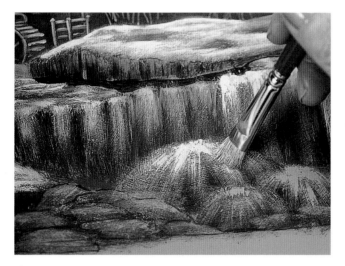

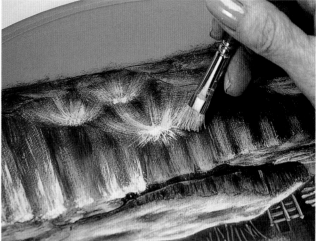

40 Tap Hi-Lite Flesh over the Blue/Grey Mist splashes in the same way to highlight each rock. Add additional highlights to the splashes by tapping more Hi-Lite Flesh in the center of the splash with the tip of the ⅜-inch (10mm) blade. Pull down.

41 Turn the plate upside down and tap more Hi-Lite Flesh to the top of the rocks using the tip of the ⅜-inch (10mm) blade. Pull up and out in a fan shape with short, quick strokes using the tip of the blade.

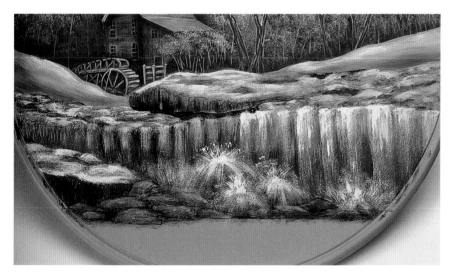

42 Add some foam at the ends of the splashes with the tip of the blade and a scant amount of Hi-Lite Flesh. The smaller rocks at the base have very little water splashes and foam.

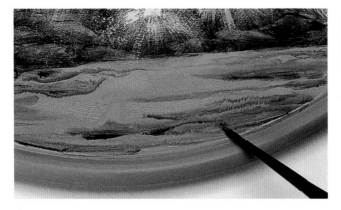

43 Paint thin Blue/Grey Mist on the river using the 1-inch (25mm) flat. While wet, add horizontal ripples of Deep Midnight Blue with a squiggle stroke using the no. 3 round.

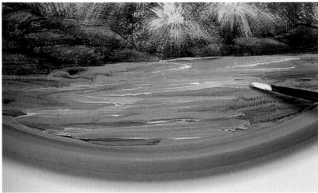

44 While the river is still wet, add Hi-Lite Flesh squiggle strokes mainly in the center in the same way. Let dry.

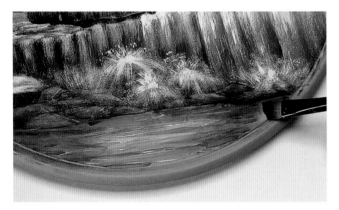

45 Dampen the river and glaze under the rocks for a reflection using Asphaltum side loaded on the 1-inch (25mm) angular. Let dry.

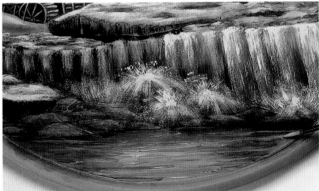

46 Repeat using Black Plum. While still wet, add more Blue/Grey Mist horizontal squiggle strokes with the no. 3 round.

Paint in the trickles with Blue/Grey Mist linework at the base of the rocks next to the river with the no. 1 liner.

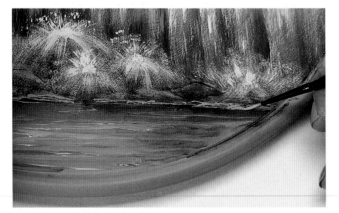

47 Dampen the river and add more Hi-Lite Flesh ripples using the no. 1 liner and horizontal squiggle strokes. They will show movement mainly in the center area. Let dry.

Glazing

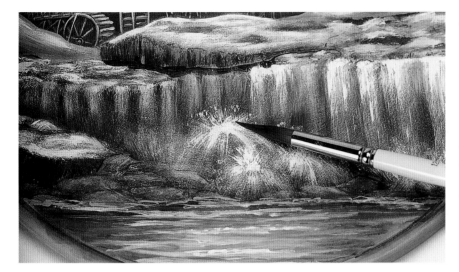

48 Dampen the surface. Paint a glaze of very thin Deep Midnight Blue to the base of the waterfall and to separate the cliffs—you must horizontally stroke on the glaze—using the 1-inch (25mm) angular. Wipe the glaze off the splashes and foam with a clean, damp no. 12 round brush. Let dry. To darken the waterfall, reapply the glaze to cliffs one, two and six using the no. 12 round.

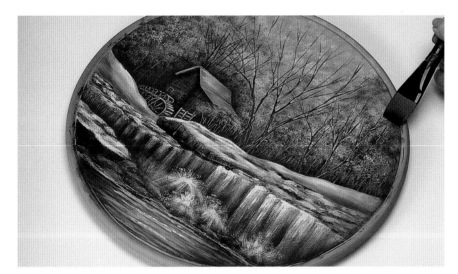

49 Dampen the entire right side of the plate. Place a large crescent-shaped shadow along the right edge of the scene using a side-loaded 1-inch (25mm) angular and thinned Deep Midnight Blue. This will darken and recede the edge of the scene, drawing attention to the mill and trees.

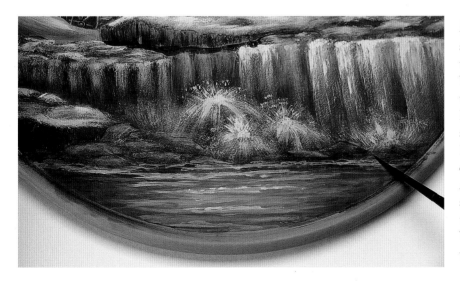

50 Paint another crescent shape along the left edge in the same way using a float of Black Plum. Glaze the base of the rocks at the river edge using the no. 3 round and thin Black Plum. Let dry. Paint linework detailing around the rocks to separate using Black Plum on the no. 10/0 liner. Let dry and glaze over the rocks with Asphaltum on the no. 3 round. Apply a thin glaze of Deep Midnight Blue to the entire river to cool and darken. Wipe off highlights in the center area with the clean, damp no. 12 round.

Critique

Let's evaluate the painting and make some additional paint applications. Each of the following sixteen steps will improve the dimension and further cool the tone of this winter landscape.

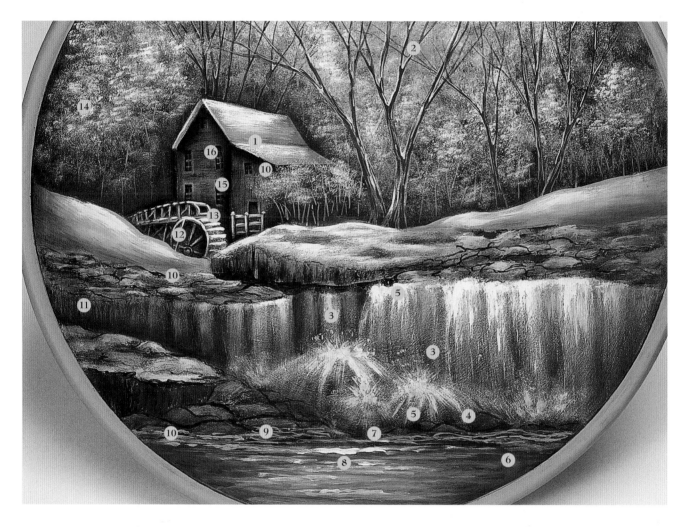

1. Highlight roofs with dry-brushed snow using the ⅜-inch (10mm) blade tip.

2. Add more Hi-Lite Flesh (snow) linework to the two large trees.

3. Glaze additional shading between cliffs one and two and cliffs two and three.

4. Reshade the base of the waterfall using Deep Midnight Blue.

5. Add more water and splashes off the foreground rocks.

6. Reglaze reflections using Black Plum.

7. Add tints of Black Plum and Asphaltum under the splashes.

8. Add additional Hi-Lite Flesh ripples in the center area.

9. Add more Blue/Grey Mist trickles on the base of the river rocks.

10. Add Black Plum linework on the cliffs and river rocks.

11. Darken shading with Deep Midnight Blue.

12. Detail and shade using Soft Black.

13. Add more snow on the wheel and framework.

14. Tap more highlights on the snowy trees using the ⅜-inch (10mm) crown.

15. Add additional Soft Black shading on the corners and under the roof.

16. Shade windows and door with Soft Black at the tops. Outline if necessary.

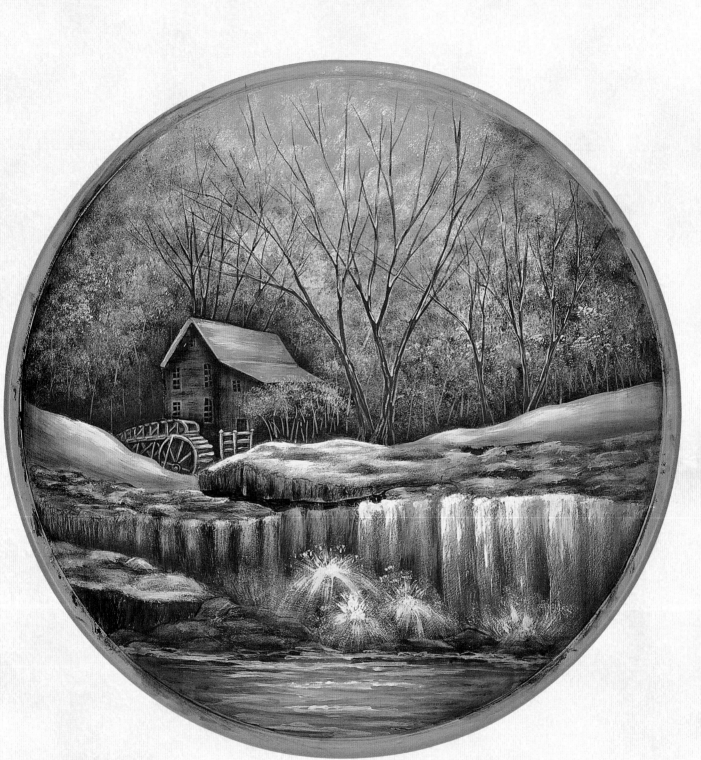

51 This plate is wonderful for serving cakes and cookies. Just be sure to properly varnish all surfaces, dry overnight and use a clear glass plate in the center for serving. Enjoy!

Resources

Brushes

Bette Byrd Brushes
P.O. Box 2526
Duluth, GA 30096
Phone: (770) 623-6097
E-mail: bettebyrd@mindspring.com

Royal Brush Manufacturing
6707 Broadway
Merrillville, IN 46410
Phone: (219) 660-4170,
(800) 247-2211

Sharon B's Originals
759 Slate Quarry Rd.
Rhinebeck, NY 12572
Phone: (845) 266-5678
E-mail:
SharonBsOriginals@worldnet.att.net

Paints and Mediums

DecoArt Inc.
P.O. Box 327
Stanford, KY 40484
Phone: (606) 365-3193,
(800) 367-3047
www.decoart.com

Surfaces

Crews Country Pleasures
P.O. Box 374
Thayer, MO 65791
Phone: (480) 225-8245
Fax: (480) 792-9261

Decorator & Craft Corp.
428 S. Zelta
Wichita, KS 67207
Phone: (800) 835-3013

R & M What Knots
23406 Ninety-fourth Ave. W.
Edmonds, WA 98020
Phone: (206) 542-1592
E-mail: rmary@gte.net

Valhalla Designs
343 Twin Pines Dr.
Glendale, OR 97442
Phone: (541) 832-3260

Viking Woodcrafts, Inc.
1317 Eighth St. S.E.
Waseca, MN 56093
Phone: (507) 835-8043,
(800) 328-0116
www.vikingwoodcrafts.com

Wayne's Woodenware, Inc.
1913 State Rd. 150
Neenah, WI 54956
Phone: (920) 725-7986,
(800) 840-1497
www.wayneswoodenware.com

Retailers in Canada

Crafts Canada
2745 Twenty-ninth St. NE
Calgary, Alberta T1Y 7B5

Folk Art Enterprises
P.O. Box 1088
Ridgetown, Ontario N0P 2C0
Phone: (888) 214-0062

MacPherson Craft Wholesale
83 Queen St. E.
P.O. Box 1870
St. Mary's, Ontario N4X 1C2
Phone: (519) 284-1741

Maureen McNaughton Enterprises
RR #2
Belwood, Ontario N0B 1J0
Phone: (519) 843-5648

Mercury Art & Craft Supershop
332 Wellington St.
London, Ontario N6C 4P7
Phone: (519) 434-1636

Town & Country Folk Art Supplies
93 Green Lane
Thornhill, Ontario L3T 6K6
Phone: (905) 882-0199

Retailers in United Kingdom

Art Express
Index House
70 Burley Road
Leeds LS3 1JX
0800 731 4185
www.artexpress.co.uk

Chroma Colour Products
Unit 5 Pilton Estate
Pitlake
Croydon CR0 3RA
020 8688 1991
www.chromacolour.com

Crafts World (head office)
No 8 North Street, Guildford
Surrey GU1 4AF
07000 757070 telephone for local
store

Hobby Crafts (head office)
River Court
Southern Sector
Bournemouth International Airport
Christchurch
Dorset BH23 6SE
0800 272387 telephone for local store

Index

Look for these other great decorative painting titles from North Light Books!

Learn to paint your favorite Christmas themes, including Santas, angels, elves and more, on everything from beautiful ornaments to festive albums with these nine all-new, step-by-step projects from renowned decorative painter, John Gutcher. He makes mastering those tricky details simple with special tips for painting fur, hair, richly textured clothing and realistic flesh tones. Just follow along with John to create a range of wonderful holiday heirlooms!

1-58180-105-X, paperback, 128 pages, #31794-K

Take your decorative painting to an exciting new level of depth and dimension by creating the illusion of reality—one that transforms your work from good to extraordinary! Patti DeRenzo, CDA, provides a complete course in the basic techniques of realistic painting, plus 6 exciting step-by-step projects that will change the way you see, the way you think and the way you paint.

0-89134-995-2, paperback, 128 pages, #31661-K

Enhance every room in your home with these easy painting projects! Donna Dewberry shows you how to master her legendary one-stroke technique for painting realistic flowers, fruits and other decorative motifs. You'll learn how to execute every stroke with confidence—from adding fine details to highlighting for enhanced depth and dimension. Guidelines for matching color combinations to existing room schemes enable you to customize every project to fit your décor!

ISBN 1-58180-016-9, paperback, 128 pages, #31662-K

Put a bounty of fresh-picked fruit in your paintings, from blueberries and cherries to apples, bananas and melons. Elizabeth Hayes, CDA, provides detailed, friendly instructions and twelve step-by-step projects that show you how to paint fruit that looks good enough to eat. Whether you're an absolute beginner or an experienced painter, you'll learn to fill your home with luscious, mouthwatering fruit.

1-58180-078-9, paperback, 128 pages, #31660-K

These books and other fine North Light titles are available from your local art & craft retailer, bookstore, online supplier or by calling 1-800-221-5831.